fine art WEDDING photography

How to Capture Images with Style for the Modern Bride

Jose Villa & Jeff Kent

AMPHOTO BOOKS
an imprint of the Crown Publishing Group
New York

Published in the United States by Amphoto Books, an imprint of the Crown Publishing Group,
a division of Random House, Inc., New York.

www.crownpublishing.com
www.amphotobooks.com

PAGE 2: *The bride looked down as her mother helped her put on her shoes. With light shining from her left, through her veil, I captured this beautifully backlit image. The open aperture and slow shutter speed allowed the light to wrap around my subject while outlining her features in profile.* Contax 645, 80mm lens, ISO 200 f/2, at 1/15 sec. Fujifilm Neopan 400 film rated at 200e

AMPHOTO BOOKS and the Amphoto Books logo are trademarks of Random House, Inc.

Library of Congress Cataloging-in-Publication Data

Villa, Jose, 1980-
Fine art wedding photography : how to capture images with style for the modern bride / by Jose Villa and Jeff Kent.
p. cm.
Includes index.
ISBN 978-0-8174-0002-6
1. Wedding photography. I. Kent, Jeff, 1974- II. Title.
TR819.V55 2010
778.9'93925--dc22
2010034580

Printed in China
Design by Kara Plikaitis
Cover Photographs by Jose Villa
10 9 8 7 6 5 4 3 2

First Edition

Acknowledgments

JOSE VILLA

I would like to thank my partner, Joel Serrato, for his continued love and support.
Without him this would not have been possible.
My deepest gratitude goes to my family for supporting my passion for photography.
Thank you, also, to the best assistant in the world, my baby sister, Nancy, who has been
with me since the very beginning.
Film, you make me so happy. Thank you to Fujifilm for making the
best film in the world.
Also, thanks to Richard Photo Lab in Los Angeles for being the best photo lab ever. You
always pull through, even under my craziest deadlines, and for that I am profoundly grateful.

JEFF KENT

Many thanks to the fine team at Amphoto Books. In particular, thanks to Julie Mazur
for identifying and pulling this story out of us, and to Carrie Cantor for her tireless
work shaping the final content.
My contributions to this work would not have been possible without the education
and support I have received from the Professional Photographers of America and the
excellent team at *Professional Photographer* magazine, especially Cameron Bishopp, Leslie Hunt,
Joan Sherwood, Debbie Todd, Karisa Gilmer, and all of my past and present colleagues who
have dedicated themselves to helping photographers succeed.
Of course, my sincerest appreciation goes to my wife, Kari, a wonderful partner,
mother, and person, for patiently listening to all my gripes about this and every other project.
And to my inspiration, Little O, whose smile motivates me each and every day.

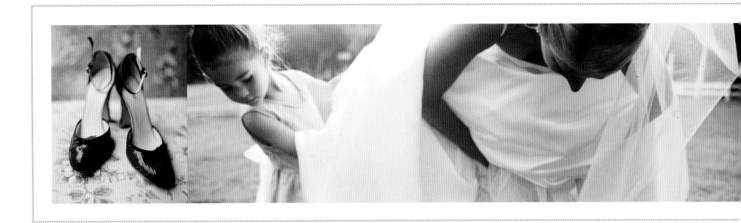

part 1
the
fine art
approach

part 2
the
stages of
the day

contents

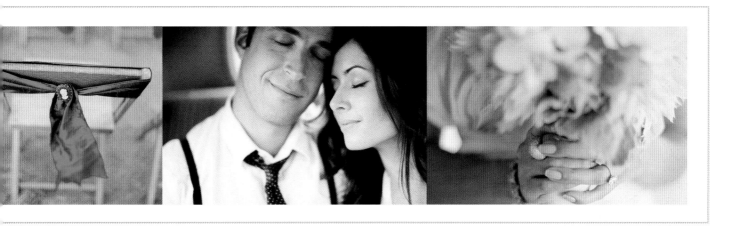

part 3

the
business
of fine art
wedding photography

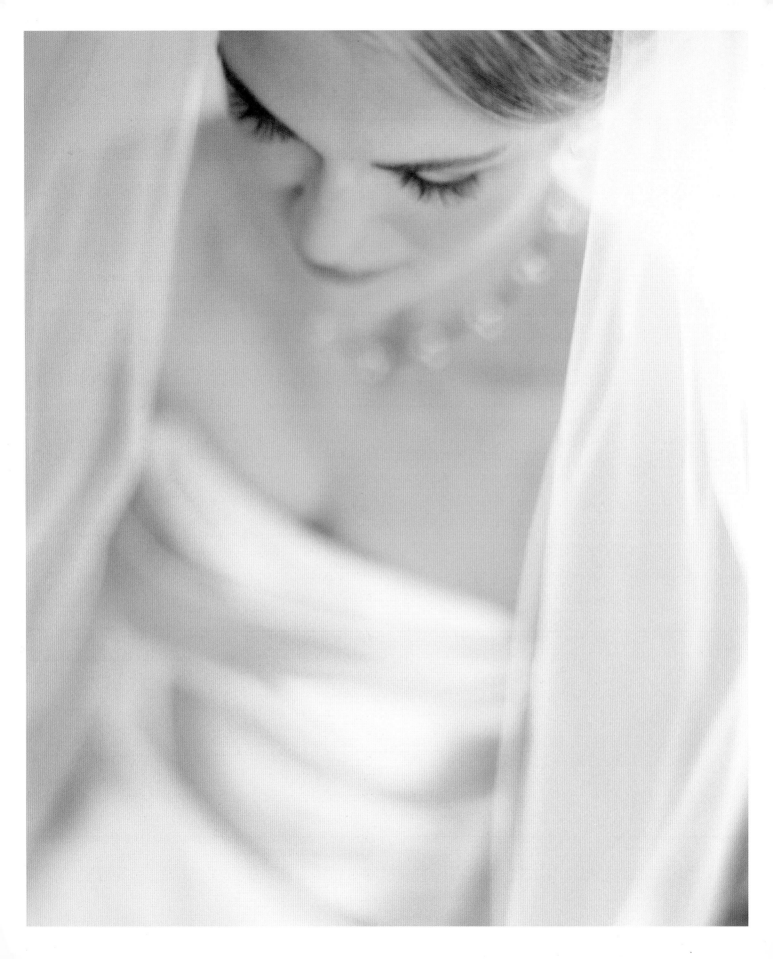

Preface

Photography has become an increasingly vital part of wedding design.

OPPOSITE This image was captured in a dark church with one small window high above and to the right of the subject. Aside from the small window light, the only other illumination was a funky little tungsten light. After placing the subject in a spot that combined these two light sources, the exposure was made with 800-speed film rated at 400, overexposed one stop with a widened aperture for a shallow depth of field. Contax 645, 80mm lens, ISO 400, f/2 at 1/30 sec. Fujifilm 800 NPZ film rated at 400

In today's wedding market, design is paramount. Modern media have influenced the tastes of couples and created a sense that weddings are more than a ceremony and a party. Contemporary weddings are cohesive, thematically designed events that couples use as an expression of their personality.

Photography has become an increasingly vital part of the wedding design. Today's most successful wedding photographers do more than merely document; they craft images artistically to fit a comprehensive design. A couple chooses a photographer based on how his or her style fits into the overall vision for the wedding and how well he or she can integrate the image creation into the theme of the event. To reach the upper tier in today's wedding market, photographers must be well-rounded professionals who understand the many elements that need to come together at a wedding. They must have a sense of the grander scheme and be able to contribute to the overall look and feel of the event.

This is the reality of today's wedding photography, especially high-end wedding photography. However, this role for the wedding photographer didn't evolve overnight. For decades, wedding photography had a reputation—fair or not—for being static and overly posed. Far too often, wedding images were those stiff shots for which families lined up like they were facing a firing squad. Then, in the 1990s and early part of this century, photojournalism swept across the industry like a monsoon flood—slowly, surely changing the landscape of modern wedding photography. Photographers turned the paradigm on its head, eschewing the old approaches in favor of candid imagery created with limited photographer-subject interaction. The new school of documentary wedding photographers often ignored—or dramatically adapted— traditional posing rules and lighting techniques. These photographers didn't look to wedding or portrait photographers as their heroes—rather they sought inspiration from photojournalist icons like Henri Cartier-Bresson, Robert Capa, Alfred Eisenstaedt, Margaret Bourke-White, and W. Eugene Smith. Concepts like "slice of life" and "moments in time" filled marketing language as photographers billed themselves as fly-on-the-wall documenters whose free-flowing approach appealed to the tastes of young couples.

The change in style also ushered in a change in perception about wedding photography. No longer seen as the vocation for conservative practitioners adhering to age-old guidelines, wedding photography was suddenly fun, adventurous, and creative. There was a freedom to the work that hadn't been present in decades. As a wedding photographer, you didn't have to spend all day snapping posed shots of extended families. You were free to roam, to document, to apply your unique eye to the event.

The pay improved as well. By bringing a new level of energy and motion to the work, industry leaders were able to demand five-figure rates while attracting clients from America's most elite circles. Not surprising, when rates started to increase, so did the number of wedding photographers. It seemed easier than ever to make a living from photography, and shutterbugs from all walks of life started migrating to the wedding market.

The role of digital imaging can't be underestimated in this process. Easy-to-use automated digital cameras significantly lowered the barrier to entry, as did Adobe Photoshop and a host of digital-imaging software that helped photographers skip the lab altogether. Digital workflow issues aside, it was simpler than ever to become a pro wedding photographer. As a result, thousands of new practitioners entered the field, and the market began to swell at the middle.

The influx of new photographers proved to be both good and bad. On the one hand, the new photographers brought a much-needed youth movement to the field. Fresh ideas, approaches, and energy poured into the marketplace. Styles, techniques, and technology changed more in a decade than in the entire previous century. On the other hand, competition for established pros went up while the industry's overall standards of quality went down. Many of the new pros lacked any true photography training. Seeking a quick buck, they fired from the hip and hoped that their "spray and pray" shooting technique would yield enough lucky gems to earn them a happy payday. This wasn't photojournalism—which involves careful consideration of where to place the camera, how to compose, and when to expose—it was snapshot photography, candid images that lacked any real sense of artistic planning or professional exposure principles.

Digital capture accelerated this trend. As digital SLRs became faster, better, and cheaper, photographers found it easier—and more affordable—to shoot thousands of frames per event. Documenting the life of a wedding became an exercise in rapid-fire capture as photographers clicked away in search of those defining moments.

The marketplace began to question the value of receiving thousands of randomly captured pictures instead of a focused, cohesive collection of photographs. As more and more wedding photographers offered base packages of simple candid imagery, clients began to grow disenchanted with the escalating prices of work they felt they could do themselves. These discerning customers started yearning for something more.

In this environment, a few progressive photographers started to expand their work into more consciously influenced styles. If photojournalism was a backlash against the meticulously posed, static wedding photography of previous generations, the newly developing styles were a backlash against the laissez-faire approach of photojournalism (and its many corrupted forms). These up-and-coming photographers considered themselves more than documenters. They wanted to affect the imagery with their unique styles. For some, this meant injecting fashion or editorial photography techniques. Others preferred to mix in environmental portraiture methods with their photojournalism. For a select few, wedding photography became the combination of fine art and real life, a stylized representation of their clients' special day in carefully shaped imagery.

Perhaps no other wedding photographer personifies the "fine artist" label better than Jose Villa. Entering the field in 2003, during the heyday of photojournalism, Jose wanted to be more of an artist than the trends allowed. Standing back and snapping away felt unnatural. Jose wanted to step in, involve himself in the scenes, and make images with his unique vision. The images still had life, movement, and emotion—they weren't statically posed, by any means—but they also had the subtle touch of the artist's hand. Jose *crafted* images instead of *taking* them. He shot with wide-open apertures for a shallow depth of field and a warm glow from natural light. He overexposed his film to bring in more light and create a pastel palette of colors. Nothing in his portfolio looked like a snapshot. While most photographers were buying the fastest digital cameras they could find, Jose worked deliberately with a slow, loud Contax 645 and medium-format film. Everything had a natural feel, yet the images were enhanced, idealized in a way that clients found flattering.

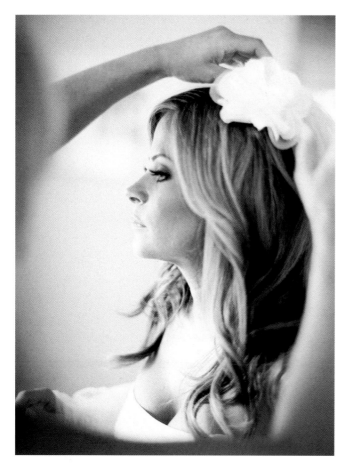

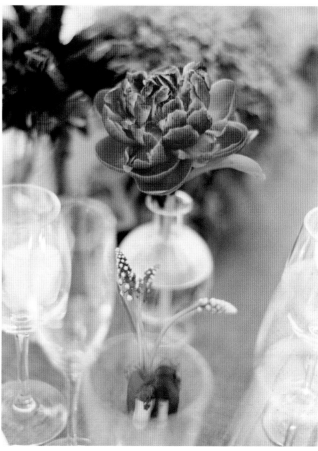

The approach was progressive for the time, and it established a toehold among a group of selective clients. As wedding photography slowly began to shift away from pure documentary styles to more comprehensively designed imagery, Jose was on the leading edge. In a field where professionals are constantly looking to distinguish themselves, Jose had carved a highly successful niche that appealed to progressive clients—artists, filmmakers, other photographers—all of whom were willing to pay a premium for his services.

The style played well in the media as well. In fact, it has become the defining look of editorial wedding coverage over the past several years. Jose's fine art wedding photography portrays the easy, fun, lifestyle look that magazines want in their pages. The images are well crafted technically and appealing artistically, yet fluid enough to show the wild emotional component of a wedding. Jose thinks of a wedding as a cohesive event with a common design theme. His images capture more than just smiles and tears; they represent the colors, the details, the sense of place. It's no wonder that bridal and photography magazines started lining up to publish his work. Publications like *Martha Stewart Weddings, Brides, Grace Ormond Wedding Style, Elegant Bride, InStyle Weddings, Inside Weddings, Modern Bride, Town and Country Weddings, PDN, Professional Photographer,* and *American Photo* have all come calling, as have wedding bloggers, photo websites, and

LEFT Framed by a bridesmaid's arms, the bride had her flower placed in her hair right before she walked down the aisle. Shallow depth of field blurred the arms and put focus on the bride's face and hair. It also created a smooth backdrop so that the detail on the bride's face and head stand out in the composition. Contax 645, 80mm lens, ISO 200, f/2 at 1/125 sec. Fujifilm Neopan 400 film rated at 200

RIGHT Good detail shots are essential for setting a scene. They're also popular with editors of bridal magazines and blogs, who want to show the full experience of a wedding. If you want to get published, make sure to include these key scene-setters. Contax 645, 80mm lens, ISO 200, f/2 at 1/500 sec. Fujicolor Pro 400H film rated at 200

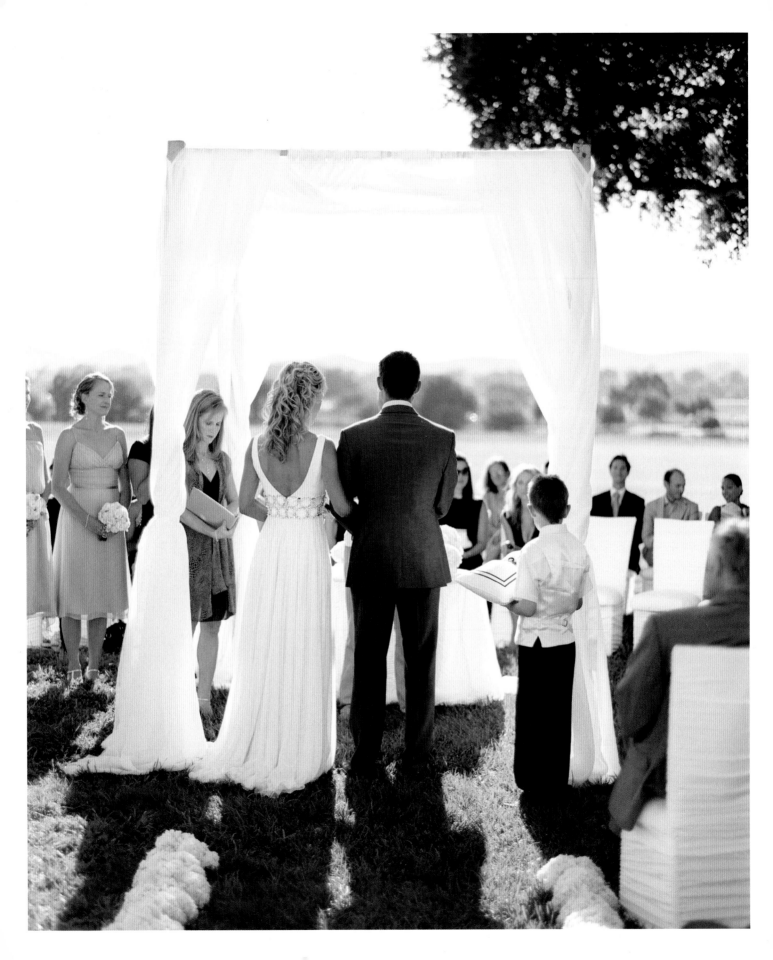

a bastion of commercial clients. Before too long, Jose was earning accolades reserved for the most elite photographers in the field. In 2008, *American Photo* named him one of the top ten wedding photographers in the world. In 2010, *PDN* put him on its list of the thirty most influential photographers of the decade.

When Jose approached me about coauthoring this book, the challenge of helping this artist tell his story was irresistible. As a longtime photography magazine editor and freelance writer, I've spoken with thousands of pro photographers. Few, if any, are as comfortable with their unique artistic vision as Jose is. That confidence, coupled with an undying dedication to his craft, is truly inspiring in a field where many practitioners are content to simply follow trends to a paycheck. Hopefully, this book offers a taste of that inspiration.

In the pages that follow, we present a progressive vision of wedding photography told from Jose's distinctive perspective. Starting with the specifics of the fine art approach, we move through practical application and into the vital concerns of applying the approach to a profitable business. We outline how this artistic philosophy suffuses everything Jose does, and how a cohesive assemblage of artistry, personality, and service can help you create a successful wedding photography business. Ultimately, we offer a series of lessons for professional photographers seeking to improve their work and move to a more upscale level of clientele.

Enjoy the discussion. Try some of the techniques. Expand your viewpoint of what wedding photography is and what it could be. If the inspiration finds you, use these insights to develop your own brand of fine art. Inspiration isn't easy, and it doesn't come to those who aren't looking for it. But it's out there waiting to be discovered. We hope our book will help you find your personal inspiration and all the success that comes with it.

—Jeff Kent

OPPOSITE This image shows a backlit scene shot during a midday wedding. Exposing for the shadow and using a relatively quick shutter speed help keep the detail in the image without washing it out with excessive light. Contax 645, 80mm lens, ISO 200, f/2 at 1/2000 sec. Fujicolor Pro 400H film rated at 200

As Jose shows us, a cohesive assemblage of artistry, personality, and service can help you create a successful wedding photography business.

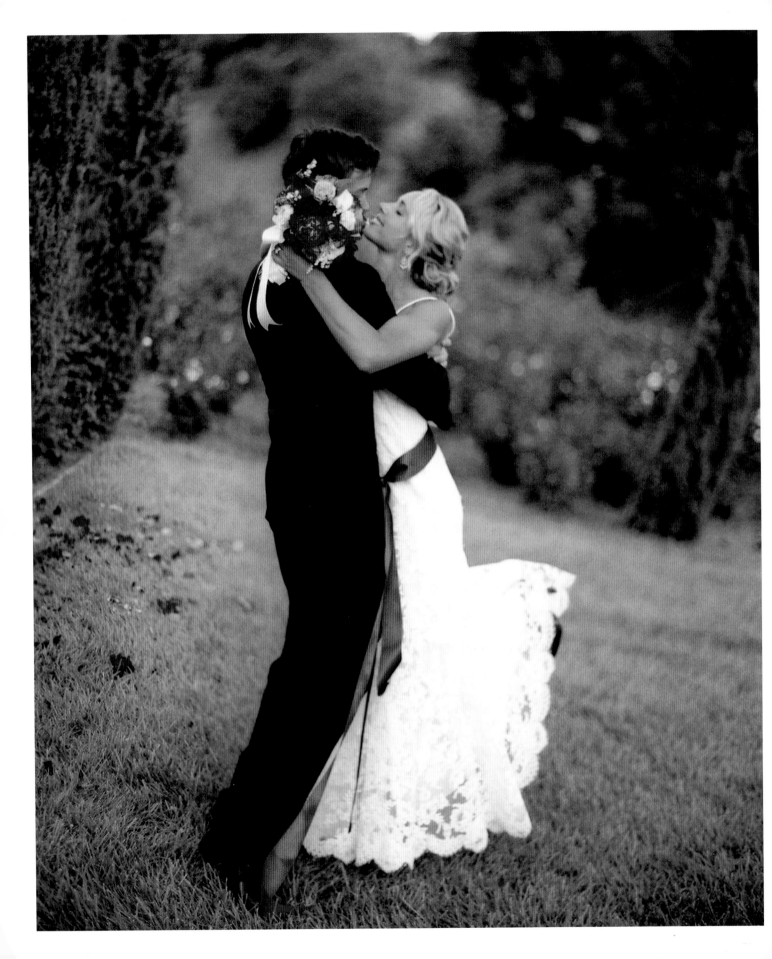

Introduction

The roots of my fine art approach stretch back to my childhood. Born in Mexico and raised on a horse ranch in Santa Barbara County, California, I grew up in a world of warmth and light. My childhood is full of memories that color my work today. I remember the animals—horses, deer, cattle—roaming the fields as breezes washed up the valleys from the coast. I remember when a little creek on the ranch would turn into a rushing river just after a hard rain, and my friends and I would jump into makeshift canoes and brave the miniature rapids. And I remember color. Palettes upon palettes of color. There were deep green trees framed against backdrops of true blue skies. There were warm yellows of grain sewn across the fields. There were rich earth tones bathed in the nearly pastel hues of the Southern California sunshine. These are the scenes, the feelings, the pastoral images that I try to recreate in my work today.

After graduating from Brooks Institute of Photography, I took my traditional photographic training and applied a sense of freedom and natural ease that I based on these childhood images. I want my work to portray subjects enjoying genuine happiness, framed in compositions of vibrant color. This aesthetic has attracted a growing fan base among progressive couples who share my attraction to the outdoors and to a joyous injection of light.

The fine art approach is about creating a cohesive collection of artistic images. It's more than documentation. It's more than candid imagery. It's about integrating the personalities of the subjects with the setting to craft distinctive images that illustrate the unique appeal of each event.

So much of the fine art approach lies in my use of light. The warm glow in my imagery comes from a specific set of exposure principles and a careful use of film. Yes, I shoot film—not as a throwback to a bygone era but as a way to create a hand-crafted look. By combining a calculated overexposure with specific composition methods and a careful selection of film, I can produce a color palette rich with pastel hues. Soft light wraps around my subjects and illuminates them in a flattering radiance. With black-and-white images, I adhere to the same basic principles but play with light and shadow, tones and motion, as opposed to color. Throughout the process, my foundation remains the same, although I may tweak the techniques to maintain a consistent look to the images.

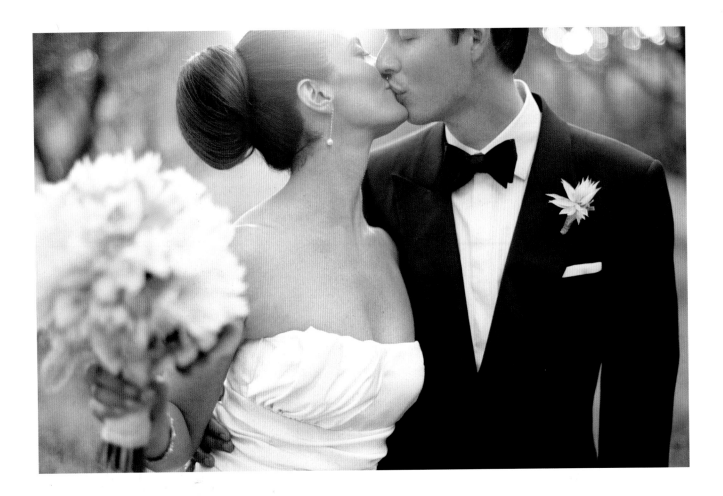

PAGE 14 I asked the bride to jump into the groom's arms and kiss him. Right before they kissed, I captured this photograph by exposing for 1/250 second. Light came from late-day sunlight. Contax 645, 80mm lens, ISO 200, f/2 at 1/250 sec. Fujicolor Pro 400H film rated at 200

ABOVE Style and emotion are consistent themes in the fine art approach. I want to create an idealized, romanticized world for my clients. In this image, I exposed for the shadow and clicked the shutter as the bride and groom leaned in and kissed each other. Contax 645, 80mm lens, ISO 200, f/2 at 1/125 sec. Fujicolor Pro 400H film rated at 200

OPPOSITE As the bride got dressed with some help from her mother, this image developed naturally. This is a prime example of the fine art approach in action; my goal is to turn busy, hectic and distracting into simple, elegant and beautiful. Contax 645, 80mm lens, ISO 1600, f/2 at 1/125 sec. Kodak T-MAX 3200 film rated at 1600

This consistency is critical to the fine art approach, and it carries through everything—the images, the overall style, the products, and the service. Remember, the fine art approach is about creating a cohesive collection of art that works together. It's also about creating an exceptional experience from beginning to end. From the clients' viewpoint, everything should be unified and of impeccable quality.

The fine art approach isn't a model that needs to be mimicked exactly. It's a framework, a mind-set. The fine art approach is less about aperture settings and focal lengths and more about creating stylish imagery and an inspiring business model. Reaching a higher level in the ultracompetitive world of wedding photography means standing out (in a good way) and establishing a consistent customer experience across the board. As more and more photographers flood the field with new digital SLRs and a couple of weekends of training, the fine art approach offers a more artisan vision that discerning clients find appealing. In today's marketplace, that artisan vision has real value. If you can present yourself as a dedicated artist who produces unique work, clients will respond to you. I've seen it time and again in my business. You want to reach that level? Distinguish yourself. That's what the fine art approach is all about.

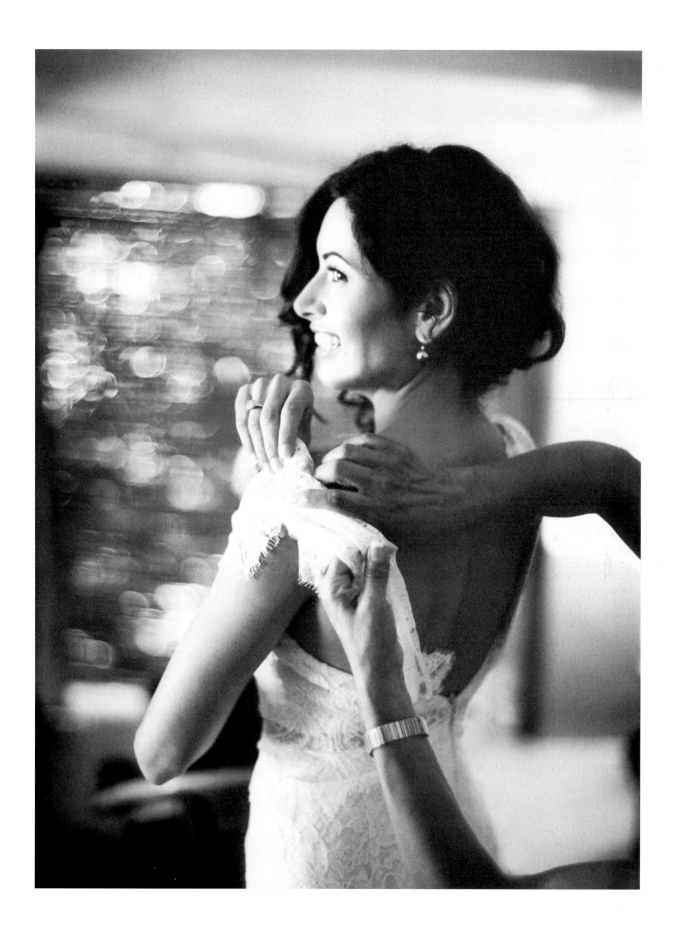

What's in My Camera Bag?

I am a film shooter. In my opinion, film offers the best medium for the specific color palette and lighting effects that define my work. But film and film cameras are simply tools. If you shoot digitally, you can apply my shooting methods, and I'll discuss the digital alternatives in several places in this book. The key difference to consider is that film and digital light sensors absorb light in different ways. When you understand how your film or sensor saturates with light—and at what rate—you can bend the traditional rules of exposure to create your custom look.

With that in mind, here's a list of the gear I use at almost every wedding.

CAMERAS

CONTAX 645 My favorite capture device, this 6 x 4.5cm medium-format film camera combines perfectly with Carl Zeiss lenses for impeccable image capture. You can use the Contax 645 with film backs, as I do, or with a digital back if you're a digital shooter.

CANON EOS-1V This 35mm SLR gives me a quicker, more nimble option for capturing candid images and working in fast-moving situations. I employ this camera throughout the day as a complement to my work with the Contax 645.

LENSES

CARL ZEISS 80MM F2.0 My primary lens for the Contax camera, this fixed lens requires me to move closer or farther from my subjects for the right composition. The lens has a depth of field that's perfect for my selectively focused compositions.

CANON 16–35MM F2.8 This wide-angle lens helps me bring in more background to incorporate scenery. It's the ideal lens for scenes in which my subjects are relatively small in the frame and the surrounding elements form the dramatic portion of the composition.

CANON 70–200MM F2.8 TELEPHOTO I often use this lens to zoom in on my subjects and crop out distracting elements, like when I want a close-up shot of an emotional expression. I also use this lens to focus on pieces and parts, such as hands held together or arms intertwined.

CANON 50MM F1.2 I use the 50mm for portraits. It allows me to get a little closer, as when I'm focusing on the eyes of a bride and the rest of the frame goes completely out of focus. Ideal for low-light situations, this lens gives a shallow depth of field but still provides that warm glow even when the lights are dim.

CANON MACRO 100MM F2.8 This lens is great for details shots, like close-ups of the rings, the invitations, cake details, flowers, and other special touches.

LIGHTS

CANON SPEEDLITE 550EX AND 580EX I bring out the Speedlites when I need to freeze action or when I'm shooting color film in very low light.

SONY HVL-20DW2 VIDEO LIGHT The Sony HVL-20DW2 is a small, versatile, continuous light source with two lights per unit. The lights have a 10-watt and 20-watt power option and are adjustable for a variety of lighting intensities. I use two of these at every wedding—one mounted on the hot shoe of my camera and another held by my assistant.

FILM

—color—

FUJICOLOR PRO 400H This film delivers natural colors and authentic skin tones. You can overexpose it by an f-stop or two, and skin tone will remain very true. Fuji Pro400H also gives a soft, pastel look with bright colors.

FUJICOLOR PRO 800Z This film tends to saturate with my exposure formula. It also gets a little contrasty in the skin tones. I use this film mostly for detail shots in low-light situations. I don't use it outside much.

FUJICOLOR SUPERIA 1600 Fuji Superia 1600 produces beautiful dusk photos. With 1600 film, I often work with flash and my camera set on Aperture Priority, which helps me capture good warm-color representation.

—black and white—

FUJIFILM NEOPAN 400 I've found this film to have more contrast than its Kodak counterpart. I overexpose Neopan 400 just like a color film. The result is strong black-and-white definition with minimal grain.

FUJIFILM NEOPAN 1600 This film is a little sensitive and not as consistent as the Neopan 400, but it provides beautiful grain. Sometimes, though, it can be almost too contrasty, so I only use it in the right lighting conditions—typically black-and-white portraits done by a window or outside when the sun is going down. I don't use this film in fluorescent or tungsten lighting because the images tend to turn gray.

KODAK T-MAX P3200 This film's grain gets exaggerated both in really low light and in very bright light, so I try not to use it in either of those extremes. But if a room is just a little dim with a bit of catch light, this grain and contrast are perfect. You have to be careful when focusing on people in the distance with this film. If they are too far, their faces start to fall apart and get lost in the film grain.

ILFORD DELTA 3200 Like the Kodak T-MAX P3200, Ilford Delta 3200 is great for low-light situations. It has a romantic, moody grain and picks up catch lights very well with my exposure techniques.

LIGHT METER

SEKONIC FLASH MASTER L-358 A basic and reliable light meter that I use in controlled lighting situations.

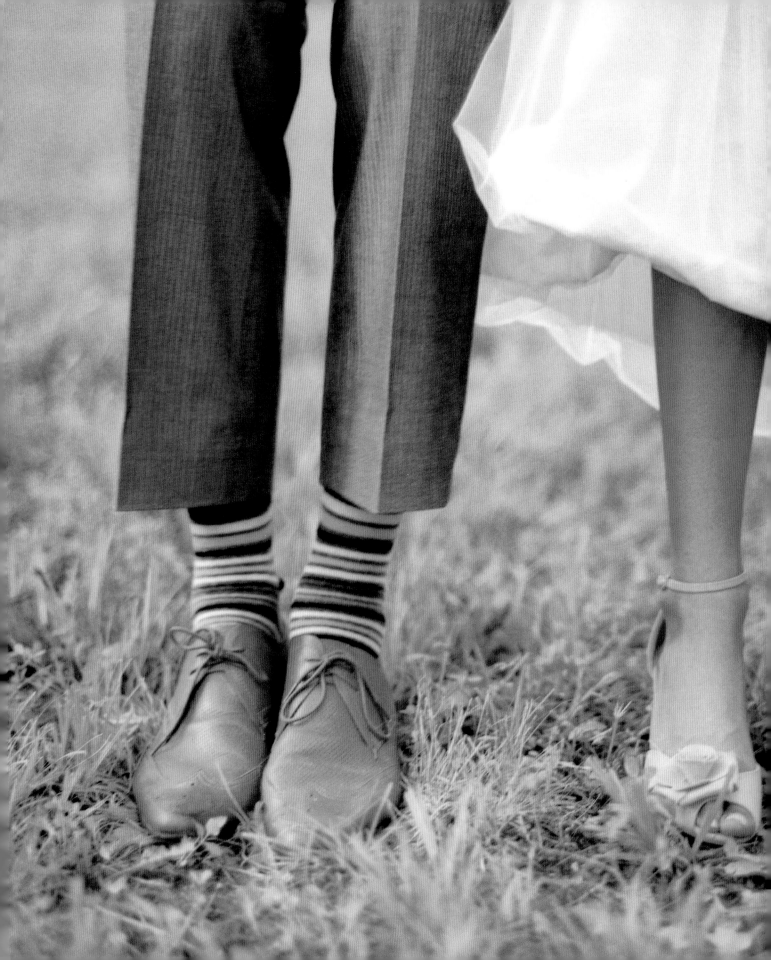

1

the fine art approach

The fine art approach is about creating a cohesive piece of art, not merely a record of the wedding day. It's about coordinating the personalities of your subjects with certain settings and specific shooting techniques to make images with distinctive stylistic appeal.

I loved the bride's shoes and the groom's socks, so I had them pose their feet for this photograph. Lighting the scene with skylight, I exposed for the shadow. Contax 645, 80mm lens, ISO 200, f/2 at 1/60 sec. Fujicolor Pro 400H film rated at 200

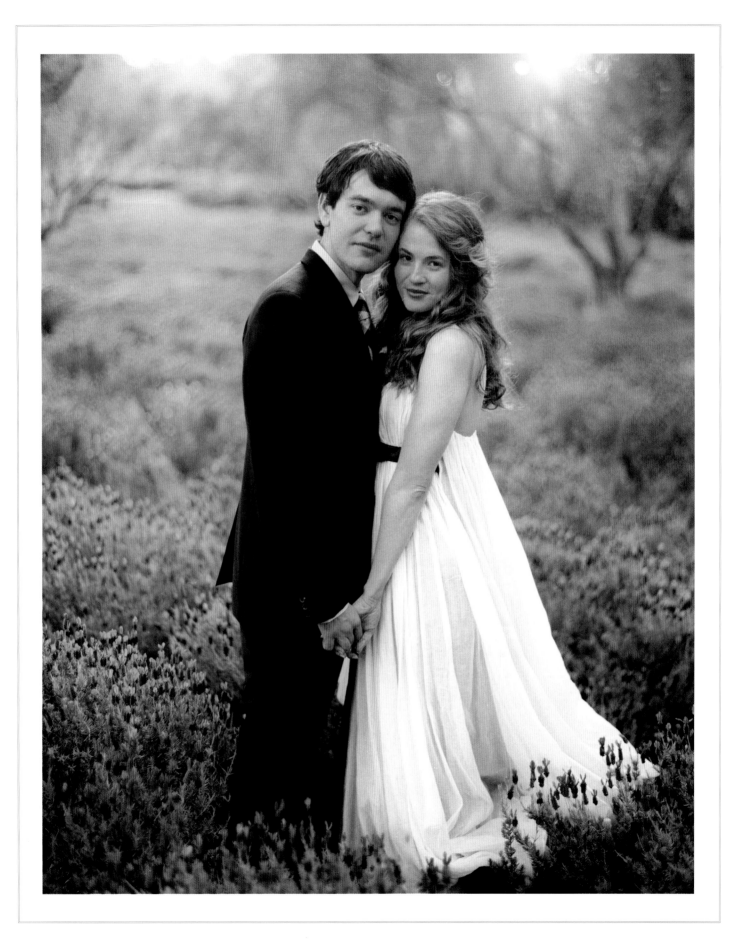

Light

For me, the underlying principle of lighting is *keep it simple*. You don't need to bring a ton of equipment to complicate things. And you definitely don't want to miss the shot because you are fiddling with your gear. Rather than manufacturing light for every situation, I bring my subjects to the good light and work more freely.

I search for four main types of light: window light, outdoor shade, backlight, and skylight. All of these are soft, warm sources of light. I avoid harsh, direct light whenever possible.

If I have to shoot outside in direct sunlight, I'll typically backlight my subjects, exposing for the shadow on their skin. That way, I take some of the sting out of the direct light and avoid color-shifting reflections from the grass, buildings, and other colorful reflectors. By exposing for the shadow, I also capture detail in my subjects' faces without needing a reflector. Also, the lighter areas aren't washed out because the light source is obstructed by the subjects. By using open apertures and longer shutter speeds, I turn that light source into a warm glow that appears to wrap around my subjects.

When I'm working indoors, I always look for window light. This soft, diffused light allows me to expose for the shadow and let the directional light wrap around my subjects to create a warm glow. But if the window is small and the room is dark, there's a lot of contrast. I don't like contrast. Strong, direct window light on my subjects' faces will make the shadow side much darker, maybe a difference of three f-stops. To fix the situation, I use

Using Natural Light

I maintain the same lighting principles throughout the day, shooting posed and candid photographs with the same core approach.

a white pillowcase or bed sheet to bounce the light back on their faces from the opposite side. A pillowcase or bed sheet provides soft, even light, and there's almost always one lying around the bride's hotel room or getting-ready area, so I don't have to worry about carrying reflectors. This is the only situation in which I use any sort of reflection in my lighting. I have an assistant stand off camera and hold the makeshift reflector on the opposite side of my subjects from the window. So if the window light is coming from camera left, my assistant stands camera right and reflects the soft, white light back up to their faces. This reduces the strong contrast between the highlight and shadow and softens up the situation considerably.

Consistency in lighting is critical. I want a smooth transition from image to image. I want photographs that look distinct but share the same lighting principles. For this reason, I maintain the same lighting principles throughout the day, shooting posed and candid photographs with the same core approach. This helps the album design process. If you have dramatic shifts in light and color, it will be difficult to put together a series of album pages, prints, or other products that work well together. I keep this in mind throughout the day, including during the transition from daytime to nighttime. By adjusting film speeds and exposure settings and bringing in just the right kinds of supplemental light (more on this later), I am able to create a consistent look.

PAGE 22 This image demonstrates my backlighting technique at midday. Working during the brightest part of the day, I placed the couple underneath a willow tree, where the long, leafy braches diffused the harsh overhead light and created some nice shade. Shooting with the sun behind the subjects, I exposed for the shadow on their faces. I let the sunlight fall on back of their heads and overexposed a stop so the light would wrap around and give off a soft glow. Canon EOS-1v, 16–35mm lens, ISO 200, f/2.8 at 1/2000 sec., Fujicolor Pro 400H film rated at 200

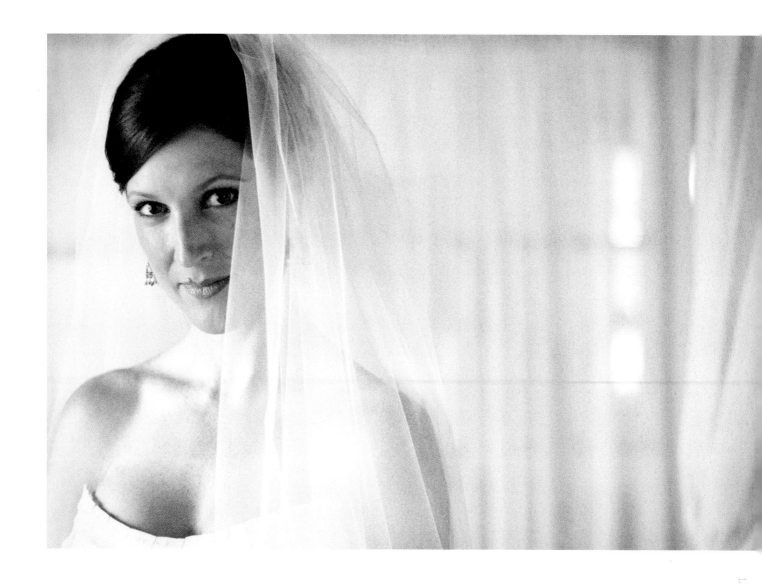

Trust is essential when it comes to lighting. Yes, trust. I spend time getting to know my clients before the wedding so that they understand me and have confidence in me. Then, when it comes time, I can pick the lighting, location, and situation that I want, and they will go with my suggestions.

I work with couples and coordinators on the timing of events to make sure I can do outdoor portraits in good light and photograph other elements at the best times of day. This includes the ceremony. If the couple chooses to do their ceremony outside on a bleak landscape at high noon, then my options are much more limited. So when I consult with my clients, I always make sure to discuss both the location and the timing of the ceremony. Remember: You have more control than you think. You are the professional hired by the clients to make beautiful images. You should speak up about the schedule and try to influence things when necessary.

With window light streaming in from camera left, I used a bed canopy to simplify the background, which had previously been a very busy situation. Exposing for the shadow on the left side of the bride's face gave this image a nice glow on her right side. Canon EOS-1v, 70–200 mm lens, ISO 200, f/2.8 at 1/160 sec. Fujifilm Neopan 400 film rated 200

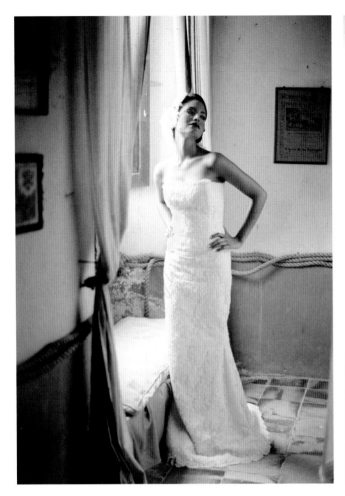

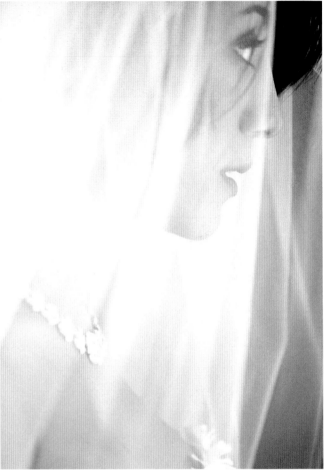

I create my best compositions when the sun is setting. When the sun has just dipped below the horizon, all you have left is residual light in the sky. I call this excellent light "skylight." It's not directional, so I can move around my subject a full 360 degrees. No matter what angle I shoot from, the light on the subject is exactly the same. During this time of day, I have the most creative freedom. I shoot like crazy because I don't have to worry about shadows or squinting or harsh light blowing out parts of my exposure. I have complete technical comfort, which I use to get as innovative as possible with my compositions. These shots end up being my clients' favorites because they flatter their faces. The combination of soft light and overexposed film makes my subjects' skin look smoother, and it helps eliminate blemishes such as under-eye puffiness.

While this time of day is great for photography, it passes quickly. In Southern California, it usually lasts about ten to twelve minutes. I always make sure to check the sunset times on the days of my weddings, and I test lighting on the evenings leading up to the events. I also take the terrain into account. A hilly or mountainous landscape could cause the sun to duck out sooner, which will bring in deep shadows much quicker.

If I have to photograph at two or three in the afternoon, when overhead sunlight is particularly harsh, I will move the subjects into a shaded area, maybe under

LEFT This room in an old hacienda had very high ceilings but only a small window compared to the size of the room. Placing the bride right next to the window, I exposed for the shadow. I had my assistant hold a white bed sheet just out of the frame camera right, which bounced soft, white light back on her face. Contax 645, 80mm lens, ISO 200, f/2 at 1/60 sec. Fujicolor Pro 400H film rated at 200

RIGHT With window light shining in from camera right, I zoomed in close on the bride's face and veil. Behind her, an orange curtain gave off a warm tone. I used a very shallow depth of field to increase the soft glow from the window light and to blur the veil. Canon EOS-1v, 70–200mm lens, ISO 200, f/2.8 at 1/160 sec. Fujifilm Neopan 400 film rated at 200

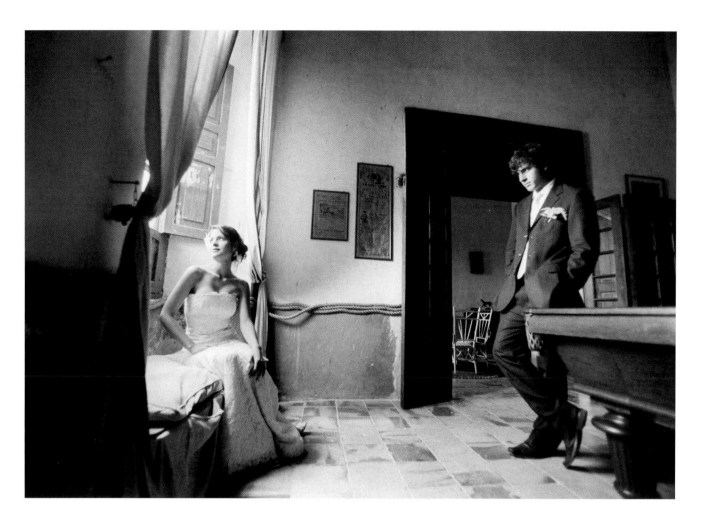

some trees. As much as possible, I position the subjects so the sun is behind them and hopefully also behind the trees. I am essentially shooting into the sun, backlighting my subjects, and exposing for the shadow.

If trees aren't available on, say, a wide-open golf course, then I will still photograph into the sun and backlight the subjects. In this case, I expose for the face. By turning them away from the sun, I'm getting a better exposure with softer, wraparound light. I'm also reducing the subjects' squinting. If you have them facing straight into the sun, then they're likely being blinded by the direct light and will be squinting terribly. Looking away from the sun helps them open their eyes and relax their expression. By exposing for the shadow in these situations, I can bring in all the detail I need in their faces and the dark areas of their clothing. No reflectors or other accessories are necessary.

I looked up while reloading film in my Contax 645 and noticed the groom watching his bride. I told him not to move, grabbed my 35mm SLR, and fired off this shot in Aperture Priority. The only source of light was the window to camera left, which allowed in soft, white light and provided some contrast from white to black. Canon EOS-1v, 16–35mm lens, ISO 800, f/2.8 at 1/125 sec. Fujifilm Neopan 1600 film rated at 800

In low light, I pull out my 3200-speed film and use long exposures to bring in warm tones and as much light as possible. That works for many compositions, but as the sun dips completely behind the horizon and guests head into reception halls with questionable lighting, I need to augment my exposures with some carefully applied artificial light. I still shoot with the same exposure principles for the same aesthetic; I just need to work a little more to get the balance of light and color exactly right.

Using Artificial Light

Video Lights

Video lights are a continuous light source often used in film and video production. They are less intrusive, because you're not popping off flashes in people's faces or interrupting unique moments with a sudden burst of bright light. For scenes with movement that is a little slower, I use a Sony HVL-20W2 video light. Video lights allow more ambient light into the image, which brings in the background. Also, as the dancing progresses and people start sweating a little, their foreheads and cheeks can look shiny in the light from a flash. Video light is softer and doesn't show the glistening on people's faces as much.

Video lights are relatively inexpensive and last a long time. Battery life is good. The Sony units I use are small, about half the size of your palm, so they're easy to maneuver. They have two lights, which allows me to more easily adjust the light intensity for different shooting situations. We carry two video lights. If the ambient light is extremely low, I mount one light on the hot shoe of my camera, while my assistant holds the other one.

During the first dance, I have my assistant hold the video light at my subjects' head level. This allows me to capture several images of this important part of the wedding without annoying my subjects with a lot of paparazzi-like flashes. The

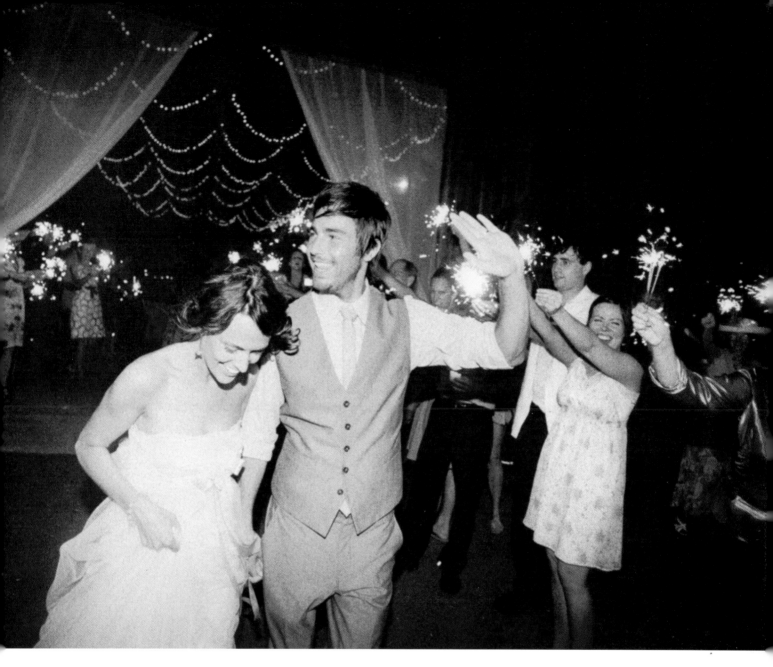

video light also allows me to create images with a soft-focus motion blur. I'll drag the shutter just a little to create a sense of movement and bring up ambient light from the background. A good portfolio of fine art wedding images mixes these types of shots in with some sharp-focus, stop-action photography for a good overall assortment.

Another reason I like video light is that you can see the direction of the light as you're shooting. You turn it on and shine it on a subject, and you can see where the light is most intense and where the shadows fall. With flash, you don't see until after you click the shutter, so you're constantly adjusting after the fact.

Also, flash intensity changes with your distance to the subject and the other factors in the room. Using flash effectively is a very mathematical enterprise; there's a lot to think about. With video light, you have a lot more control. It simplifies the situation, and, as I have said, keeping it simple is central to my style of lighting.

I photographed this bride and groom during their grand exit using a Canon 550EX flash on my Canon 35mm camera. I set the camera to Aperture Priority to pick up a little of the background light. In this mode the shutter stays open a bit longer than it will in Program mode, allowing in some ambient light, which illuminates the background while the subjects are lit by the flash. The little bit of motion blur in this image was done intentionally to show that they are running through the crowd. Canon EOS-1v, 16–35 mm lens, ISO 1600, f/2.8 at 1/4 sec. Kodak T-MAX P3200 film rated at 1600, Canon Speedlite 550EX flash

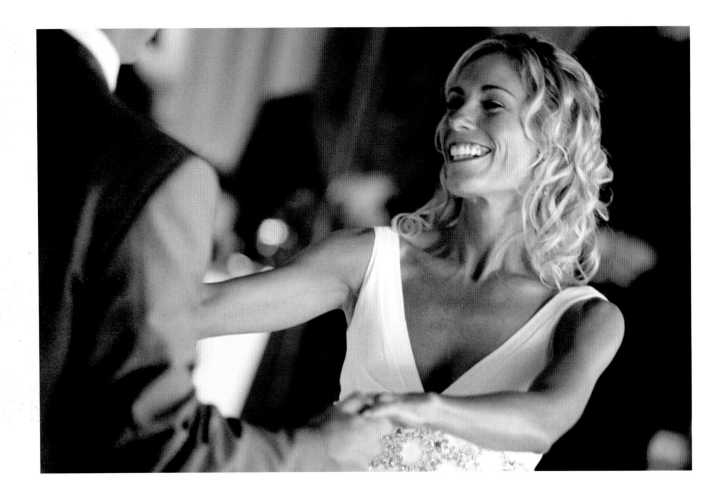

In most situations, my assistant constantly moves to adjust the video light to moving subjects. So the light moves with the subjects, instead of the photographer continually making flash-power and exposure-setting adjustments to adapt to moving subjects.

When we're working with the video light, I often stay in one place while my assistant moves the light. Or, in many situations, my assistant and I move independently of each other, often in opposite directions around the subject. Imagine a circle surrounding the bride and groom during their first dance. My assistant and I might start shoulder to shoulder on one edge of the circle, with the video light just off to the side of my camera. As the couple start dancing, my assistant starts moving along the circle in one direction, and I move in the opposite direction around the circle. I'll end up shooting right into the light, which creates a beautiful flare.

I love flare. A lot of photographers avoid flare because

it's not technically correct, but I think it's an attractive effect. I actually seek out situations where I can shoot into the sun or into lights, and I intentionally create flares for dramatic impact.

When I'm working with video light, I'm shooting more or less like I'm outside. I have my camera set to Aperture Priority with a wide-open aperture. I expect some motion blur from moving subjects, and that's part of the plan. I want a little softness in my first-dance shots. It gives the images a little more of an emotional feel; it's not a freeze-frame with the subjects frozen in time.

When I work with the video light, I usually photograph in black and white with high-speed film (mostly 3200 rated at 1600). I don't have color films that are that fast; my fastest color film is 800 speed, rated at 400, which is too slow for my shooting formula with a video light. If I need to shoot in color during lower-light situations, then I use my Canon Speedlite flash to freeze the subjects.

Flash

I try to avoid flash as much as possible. I don't use flash at all to enhance photos during the day. My flash stays in the bag until the reception when the light is very low. But for faster-moving scenes or when I need to shoot color film in low light, flash is useful.

I typically set my camera to Aperture Priority and my Speedlite flash to ETTL. ETTL (evaluative through-the-lens) is a flash exposure system that uses a super-quick pre-flash before the main flash to determine the correct flash exposure. The preflash bounces off the subject and back to the camera to tell the flash the appropriate amount of light needed. Then, using a feature called Flash Exposure Compensation (that's the Canon flash term; Nikon calls it Flash Output Level Compensation), I reduce the flash output level beneath the recommended setting. I do this because I don't want an overwhelming flash that blows out my subject. Flash Exposure Compensation (FEC) works in 1/3 stop increments, and can be adjusted to plus or minus 2 stops. I set my flash at FEC −1/3, meaning I'm telling the flash to operate at one third of a stop less than full power. So ETTL meters the subject and establishes a recommended flash output, and then my FEC setting automatically reduces power by 1/3 of a stop to take some of the harshness out of the flash.

The Aperture Priority setting slows the shutter speed just enough to show a little movement in the background through some slight motion blur and allows some extra light into the exposure so that the background isn't completely black. The flash freezes the main subjects in the foreground for a clear, clean shot. When you flash on regular power with auto settings, it sometimes just lights the subjects, and the background falls to black. Using Aperture Priority with high-speed films, I can bring in the background elements as well as the brightly illuminated foreground. That way I capture some of those priceless moments behind the main scene—the mom crying, the band playing, the guests laughing, the father looking on with pride.

When I want to separate my subjects from the background—maybe during some dancing scenes—then I'll set my on-camera flash to Program mode. This freezes the scene and isolates my subjects a little more.

Flash can be used in conjunction with video light to great effect. If I want to freeze the motion of my main subjects, I illuminate the scene with a little video light and then fill in with flash. If used properly, the flash can lighten up the subjects' faces and put a little catch light in their eyes. With my settings, the flash often highlights detail on the subjects, but it might illuminate only part of them, depending on exactly where it's aimed. The video light then fills in the rest of the composition.

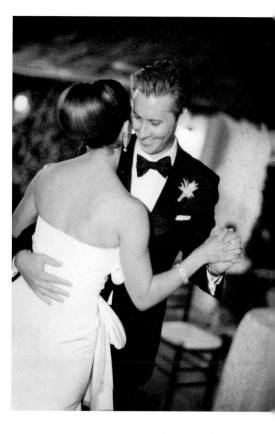

OPPOSITE For this bride and groom's first dance, I wanted a moody, grainy look for the photographs. I shot with 1600-speed press film, which I rated at ISO 800. I used my flash to stop the action and highlight the subjects. Canon EOS-1v, 70–200mm lens, ISO 800, f/2.8 at 1/30 sec. Fujicolor Press 1600 film rated at 800, Canon Speedlite 550EX flash

ABOVE Soft blur can be very romantic in a low-light situation. I captured this image with the Sony video light shining directly on the couple as they danced their first dance to a slow song. An open aperture and 1/30-second shutter speed helped bring in just enough light on the background elements to provide a romantic setting for the image. Contax 645, 80mm lens, ISO 1600, f/2 at 1/30 sec. Ilford Delta 3200 film rated at 1600

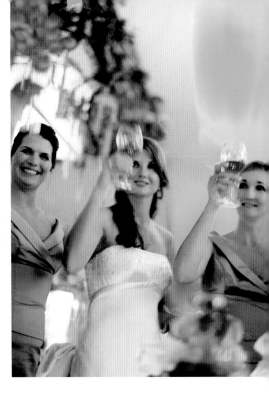

We're all thrown into situations with bad light—that's just part of the job—but by approaching lighting problems with creative yet simple solutions, you can still create striking images with that warm, soft glow that clients love.

There are seven strategies I use to make the best of bad-light situations.

Dealing with Bad Lighting

1. PROVIDE PREEMPTIVE COUNSELING. If I do a walk-through at the ceremony and/or reception site with the clients before the wedding, I always advise them about lighting situations. I have them stand in certain areas that will be part of their ceremony or reception, and I point out what the light will look like during their wedding. Then, by showing them images from other weddings, I illustrate how bad lighting can be fixed, either through professional lighting for indoor spaces or adjusting schedules for outdoor scenes.

It's important to do your walk-through at the same time of day as the event. That way you can clearly show your clients what you will be dealing with.

2. SUGGEST PROFESSIONAL LIGHTING. If the reception hall lighting is subpar, I will often suggest hiring a professional company to up-light the room. These companies put lights on the bottoms of walls that shine up the walls to create a warm glow on all the people in the room. It's expensive, often around $2,000, but if they're already spending a lot more on decorations, the dress, and me, it can be a good investment.

3. BACKLIGHT TO COUNTERACT DIRECT SUN. If I'm forced to work in harsh sunlight, I will position myself to use backlighting as much as possible. I shoot into the sun to decrease the reflection from the gown and the green tone from the grass.

4. BOUNCE VIDEO LIGHT TO COUNTERACT TUNGSTEN TONES. If the reception has bad tungsten lighting with a green or yellow tint, I use a video light to counteract those tones. My video light is daylight balanced and provides a good, even tone. I often bounce video light off a white piece of paper to up-light with a clean, white light.

5. TRY BLACK AND WHITE. If there is a wild mix of colors or terrible, color-shifting lighting in a room, I might shoot more black-and-white film because it shows softer, more emotional tones, and it eliminates that funky green-yellow tone that tungsten light can put on the skin.

6. FIGHT COLOR SHIFT WITH FILM CHOICE OR WHITE BALANCE. For those bad tungsten-light situations, rethink your choice of film—or your white balance, if you're working digitally. For me, Fujicolor 800 NPZ is great for minimizing crazy color.

7. SHOWER YOUR SUBJECTS WITH LIGHT. I will often bounce video light off of the ceiling if it's reasonably low (15 to 20 feet). Bouncing clean, white light off the ceiling lets the light shower down on your subjects. Unfortunately, this technique won't work on very high ceilings.

OPPOSITE This reception tent was lit but with tungsten lighting that turns yellow. I like some tungsten, but too much creates an artificial-looking image. Shooting with Fujicolor 800 NPZ gave me the film speed I needed while putting my exposure in a range that my lab could easily correct if a dramatic color shift occurred. Contax 645, 80mm lens, ISO 400, f/2 at 1/8 sec. Fujicolor 800 NPZ film rated at 400

ABOVE LEFT The light was very low at this reception, and I wanted to capture a romantic, moody feeling, so I bounced video light on the low ceiling and shot with a slow shutter speed. Contax 645, 80mm lens, ISO 1600, f/2 at 1/15 sec. Ilford Delta 3200 film rated at 1600

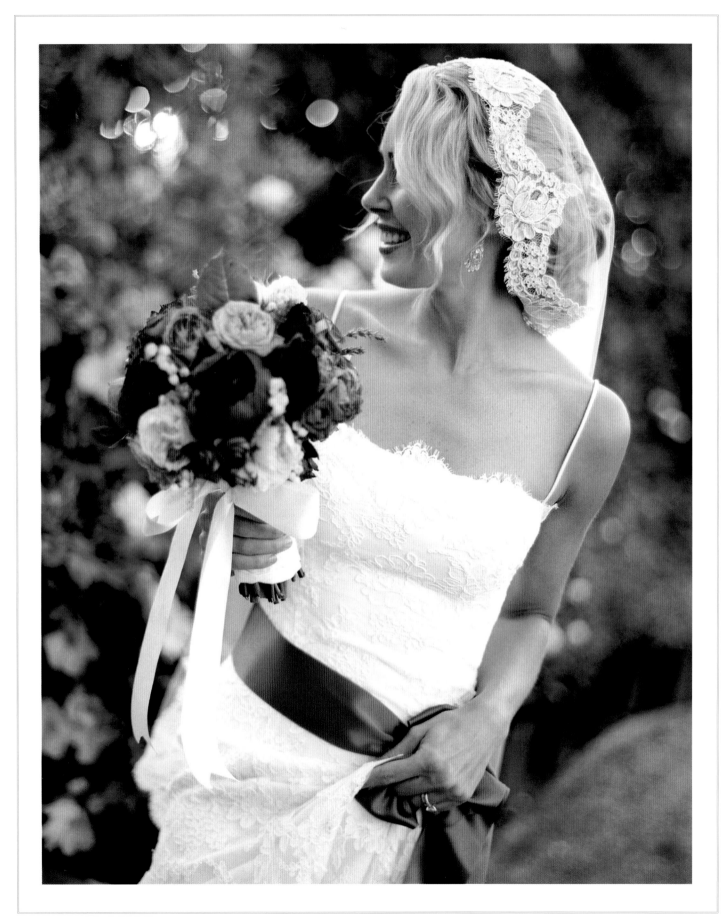

2 Exposure

The fine art look is characterized by warm tones, a soft glow, and colors that are almost pastel. Backgrounds are usually in soft focus. These features help distinguish the images from the more snapshot-type imagery that too often appears in today's wedding photography. They also lend a more distinct style to the images—subjects stand out from the background, colors are consistent, light is soft and flattering. This style creates an idealized vision that my clients find both unique and appealing. At the core of this style is a set of basic exposure principles. With minor adaptations for light, color and situation, I apply these principles at every wedding. They are as follows:

* I overexpose my images.
* I expose for the shadows.
* I photograph with my aperture wide open.

I typically overexpose my film by one f-stop to create a softer, lighter, more airy feel to the images. The more you overexpose, the more the highlights blow out and the more high-key the image becomes. The sky turns paler. Colors look more pastel. Light tends to glow softly. I like these features because they limit contrast.

Overexpose the Images

At the core of this technique is my treatment of film. I underrate each roll of film by one f-stop to provide a consistent overexposure throughout the entire roll. I do this by adjusting my camera's ISO setting to one f-stop below the speed of the film. For example, if I'm shooting 3200-speed film, I adjust my camera's ISO setting to 1600. I'm effectively telling the camera that the 3200-speed film is 1600-speed film. Once I set the ISO, I leave it at that level for the entire roll of film—I do not change it mid-roll, and I do not make adjustments with the Exposure Compensation dial.

The higher the ISO, the more sensitive the film is to light. When I set my camera's ISO setting one level down, I am "tricking" it into thinking it's loaded with a lower ISO film. It thinks that the film is less sensitive to light, meaning it requires more light to expose properly. The camera then adjusts its exposure settings to allow more light onto the film during the exposure. Since I work through Aperture Priority most of the time, this means longer shutter speeds.

To find the starting place for my exposure, I position my subjects in good light, typically with the sun behind them. I then set my camera to Aperture Priority at the f-stop that corresponds to the maximum aperture of my lens. (For example, if I'm shooting with my Zeiss 80mm f/2 lens, I set the camera to Aperture Priority at f/2.) Then, using the camera's center-weighted metering system, I aim the central metering

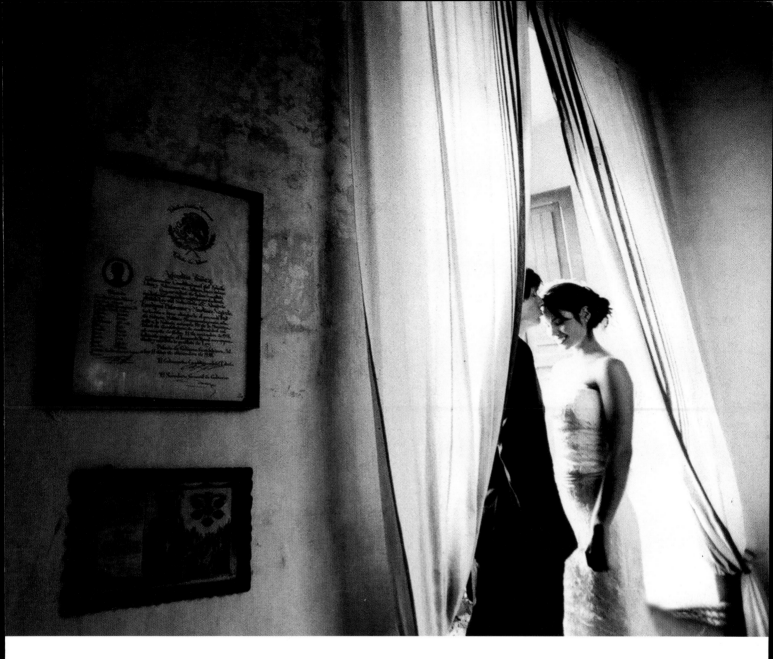

grid (center of the frame) at a shadow area on the subject's skin. I press the shutter halfway down and note the meter reading. At this point, I switch the camera over to manual and set the exposure at the meter reading. Switching to manual and setting the exposure will provide more uniform exposures, particularly in situations that have the potential for inconsistent exposures—such as subjects standing under the shade of a tree with bright sunlight all around the perimeter of the shade. In these types of situations, the camera's Aperture Priority setting will constantly adjust the shutter speed depending on the variable amounts of light in the frame. But if the light is very consistent, such as with late-day "skylight," I may just stick to Aperture Priority because the shutter speeds are not going to change. Regardless of which setting I use to shoot, I make sure to re-meter and reset the exposure on Aperture Priority every time the lighting changes.

PAGE 34 I photographed this bride at sunset as the groom went to grab his suit jacket. When she looked in his direction, I clicked the shutter, exposing with a wide-open aperture to blur the background and create a soft feel to the image. Contax 645, 80mm lens, ISO 200, f/2 at 1/125 sec. Fujicolor Pro 400H film rated at 200

ABOVE The bride and groom stood on a couch to get some nice window light on their faces. I overexposed by an f-stop to bring in the soft glow of the window light and let it wrap around them. Canon EOS-1v, 16–35mm lens, ISO 800, f/2.8 at 1/60 sec. Fujifilm Neopan 1600 film rated at 800

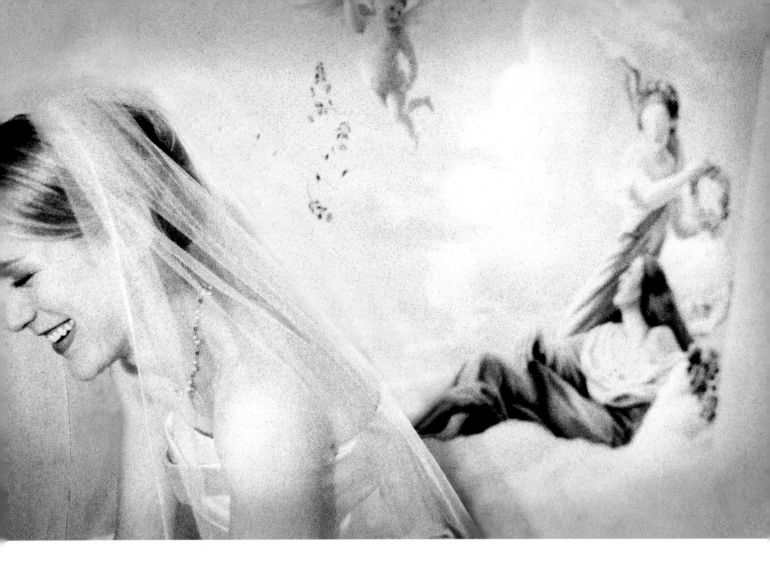

This is one of my all-time favorite images. Using 3200-speed film rated at ISO 1600, I photographed this bride laughing as we talked about when she first met her husband-to-be. Canon EOS-1v, 24–70mm lens, ISO 1600, f/2.8 at 1/30 sec. Kodak T-MAX P3200 film rated at 1600

For digital capture, the system works a little differently. Obviously, digital cameras don't employ film. So for digital capture, ISO settings refer to the ISO equivalent. The ISO setting influences how sensitive the image sensor is to the amount of light in an exposure. The higher the ISO setting, the more sensitive the image sensor.

However, digital sensors absorb light differently than film. Whereas my films continue to soak up light for a soft, warm look, many digital sensors become oversaturated at the same light levels, causing the images to wash out.

Now, this doesn't mean you can't adapt my film-based exposure principles to digital shooting. You can. You just need to test your exposures carefully so that you're achieving the right balance between overexposure and clear image capture. Throughout this book, as I discuss underrating my film to overexpose by an f-stop, try interpreting those techniques to digital capture by playing with your ISO settings and/or shutter speeds. First, set your camera to Aperture Priority at the max aperture of your lens. This will give you that shallow depth of field for a selectively focused image with a soft background. Second, determine your other exposure settings (ISO and shutter speed) based on the Aperture Priority settings your camera gives you, and then switch over to manual, keeping those same exposure settings. Next, start experimenting with your

ISO or shutter speed until you get the desired look. Adjust one or the other to make your images lighter or darker. It will take some experimentation, but you will eventually achieve the look you want. The beauty of digital is that you can see exactly what you're capturing on your LCD screen and make adjustments on the fly.

A word of warning: Overexposing tends to soften certain elements in a photograph. This can be great for reducing skin blemishes and giving people a smoother appearance to their faces, but it's a problem when you're trying to capture intricate detail because overexposing can make those fine details disappear. For example, you may find that the bride's veil almost vanishes! So, before overexposing, always take into account the position of the subject, how the light is falling, the natural contrast in the scene, and all your other photographic elements.

When shooting with this technique, be aware of your exposure settings. Sometimes in inconsistent lighting situations—particularly when metering while set on Aperture Priority—cameras will set the exposure outside the acceptable range. So monitor your exposures and adjust accordingly when settings appear out of whack.

To pull off this shooting method, you need to know your camera, trust yourself, understand your light, and get everything right in the camera. Whether you are shooting digital or with film, the less work you have to do on the computer, the better.

Exposing for the shadow, I overexposed my film by an f-stop and shot from above and behind the groom. I asked the couple to put their heads together and then focused on the bride's expression. Contax 645, 80mm lens, ISO 200, f/2 at 1/1000 sec. Fujicolor Pro 400H film rated at 200

As I discussed in Chapter 1, I usually backlight my subjects, particularly when I'm working outdoors. With the sun or some other strong light source shining from behind my subject, I expose for the shadows on their faces. This way, I'm sure to bring out the important details in their expression or attire, and because I'm overexposing my film, the backlighting wraps around the subject with a soft, warm glow. That is one of the key elements of the fine art look.

Expose for the Shadow

I use two tools for metering: the in-camera light meter and a hand-held incident light meter. In fluctuating situations with varying light, I set my camera to Aperture Priority and rely on the camera's meter. In controlled situations where my subjects aren't moving in and out of different light situations, I often use the hand-held meter. I simply walk up to the subjects, take a meter reading in the shade, and use that reading to set my exposure setting for the rest of that sequence of shots.

With digital capture, I still recommend exposing for the shadow to provide shadow detail and some warm glow from the light source. The exception is when shooting outside at midday. Digital capture tends to blow out the highlights when the light is strong and you overexpose the shot. With film you have more latitude because of options during processing—up to four f-stops with many films. I expose for the shadow 100 percent of time with film because of that latitude. Digital, however, often requires exposing for slightly brighter portions of the frame so as not to wash out the exposure.

To counteract the lack of exposure latitude in digital capture, I suggest shooting in Raw. The extra digital information lets you play with the file more and create the exact look you want. During digital processing, you can make changes to the file like a good lab would do with a film negative. I always suggest accomplishing as much of your signature look in camera as possible, but Raw capture does leave more options in case things don't come out exactly the way you planned.

OPPOSITE The sun was setting as I made this photograph at a winery in Napa, California. I exposed for the shadow and let the sun wrap around the trees. Contax 645, 80mm lens, ISO 200, f/2 at 1/250 sec. Fujicolor Pro 400H film rated at 200

I almost always shoot on Aperture Priority—or at least meter on it and then shoot on manual, as described earlier. I typically set my f-stop wide open, usually f/2 or f/1.2. In general, I shoot at the lens's maximum aperture, opening it up as wide as it will go for the shallow depth of field I prefer in my images. I use this shallow depth of field to target my viewer's eye on the main

Use a Wide-Open Aperture

point of interest and also to blur out background details. I prefer smooth, softly focused backgrounds. I want a clean canvas for my images, and a wide aperture allows me to soften the background to the point at which it forms a consistent backdrop for my compositions, almost like a painting.

Shooting on Aperture Priority isn't as simple as setting the priority and letting your camera go. You have to know your exposures to use this feature. You need to be aware of what shutter speed the camera is setting itself to. If it's within an acceptable range, I just shoot. If I see that the camera has set the shutter at 1/4000 second while focusing on subjects standing in the shade, then I know that something is wrong and I need to make adjustments. For cases in which the exposure appears to be way off, I refer to my basic daylight exposure (f/16 for 1/125 second from 10 A.M. to 2 P.M. on a sunny day) and then move my exposure settings accordingly. Typically, this means adjusting shutter speed, since I'm working on Aperture Priority. The only exception is when I'm shooting group photos in very low light.

When shooting groups in low light, be aware that a shallow depth of field tends to become exaggerated in dim situations. When I'm working in low light at f/2 with my 80mm f/2 lens, the shallowness of the depth of field becomes exaggerated to the point that it looks more like f/1.2. So, in dimmer light, I'll often bump up my aperture to make sure all the key points of interest are in focus. This is particularly relevant for large group portraits or other images that have a lot of dimension.

LEFT Right around sunset, I was chatting with this ring boy about the wedding. I accidentally dropped my second camera, which he thought was hilarious. Before I retrieved my battered gear, I shot this frame with my aperture set to f/2. A wide open aperture blurs the background into a soft canvas while my sharp focus remains on the boy's laughing face. Contax 645, 80mm lens, ISO 200, f/2 at 1/60 sec. Fujicolor Pro 400H film rated at 200

BELOW In a dark, horribly lit bathroom, the bride put on her veil with the assistance of her hair stylist. To minimize the color shift created by bad tungsten lighting, I photographed with 400-speed black-and-white film, which I rated at ISO 200. By using a wide open aperture, I lose detail in the bride's veil, which I want to do in this situation. The fabric turns very soft, almost transparent, and my focus remains on the face. Contax 645, 80mm lens, ISO 200, f/2 at 1/30 sec. Fujifilm Neopan 400 film rated at 200

Whether you use film or digital capture, it's vitally important to test your exposures and find the right formula for your way of shooting. Once you find a formula that fits your style, you can develop a consistent capture method and a consistent workflow. Then you'll always know how to shoot in certain conditions and feel confident as to how your final images will turn out. Establishing that consistency is absolutely vital to building a niche for your work and for appealing to discerning clients.

3 Color

About six or seven years ago, black-and-white wedding photography was all the rage. I love black and white and use it quite a bit in my work, but my use of color has always been one of my strongest distinguishing factors. Even when the black-and-white trend was sweeping the field, I was getting three or four calls a week from brides asking about the color in my work. They felt my color was different from anything else they'd seen and wanted that look. I received similar feedback from vendors and commercial clients.

I started to think more consciously about color and how it fits into the overall design aesthetic of my work. In a field in which originality pays off, my approach to color helped me build a niche in the high-end wedding market. These days I shoot about 80 percent color and the rest black and white. The black-and-white images serve to punctuate certain moments and bring in that timeless, classic feel. But the color images are what really draw in clients and get editors calling about publishing my work.

The point of my exposure formula is to create a soft, warm color palette. Everything I do with my exposure—overexposing by an f-stop or two, backlighting and exposing for shadow, shooting with a wide-open aperture—is intended to produce a set of signature colors.

The combination of backlighting and overexposure is critical. By overexposing my film, I can bring out

Creating a Warm Palette

details in dark areas while also achieving a nice, soft tone. If a subject is wearing bright colors, overexposing softens those colors. The backlighting provides a soft fill light that wraps around my subjects and accentuates the warm color palette.

When I'm using 400-speed film, my film of choice during daylight, I can follow this formula and the skin tones remain consistent and true to life. With 800- and 1600-speed color film, I have to be more careful. When I overexpose 800-speed film with a wide open aperture, I've found a shift to magenta in the skin tones. I pull out 1600-speed film only in very low light, mostly when the sun in setting, but I see a magenta shift in that film as well, not to mention additional grain. These films are great for lower-light situations, but I use them only in just the right lighting scenarios. If light is too low, I'll switch to black and white or employ some of the lighting techniques I discuss in Chapter 1.

For backgrounds, whether I'm shooting in a landscape or using the sky as my backdrop, I look for white, pale blue, pinks, sage greens, and yellows. The key—as I discuss in Chapter 5, Composition—is to put my subjects in a situation in which the tones are going to be soft. When working at sunset, I can overexpose and get subtle pink tones without blowing out details.

Consistency is critical when it comes to color. Consistent exposures. Consistent film. Consistent processing. Consistent printing. I use primarily Fuji films, which are processed by my lab in Fuji chemicals and printed on Fuji archival paper by a Fuji Frontier printer. At the risk of sounding like an advertisement for Fuji, I'll say that this is the winning combination for me. You may find a different combination of products and capture methods, but in my work I've achieved consistent tonality with these elements, and I don't stray from the pattern.

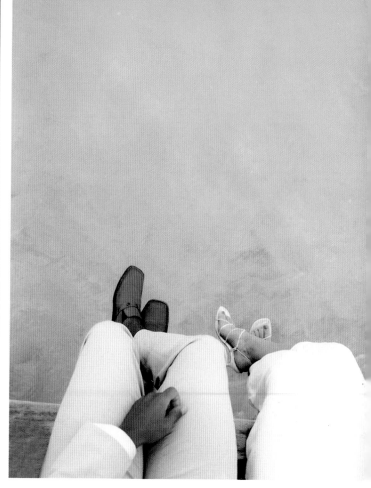

PAGE 44 This bright wall made a perfect backdrop, and it was right outside the bride's prep room. Lighting comes from skylight. I made this composition all about the interplay of her white dress and veil and the bold orange color. Contax 645, 80mm lens, ISO 200, f/2 at 1/1000 sec. Fujicolor Pro 400H film rated at 200

TOP LEFT For this detail shot, I used a macro lens and placed the ring on the bride's bouquet. Then I put the entire arrangement under a tree to get a soft look to the lighting. Canon EOS-1v, 24–70mm lens, ISO 200, f/2.8 at 1/2000 sec. Fujicolor Pro 400H film rated at 200

TOP RIGHT As this bride and groom relaxed by the edge of a dock on the island of San Pedro, Belize, I shot straight down with my normal exposure settings, composing to bring in plenty of the brilliant turquoise from the water. Contax 645, 80mm lens, ISO 200, f/2 at 1/500 sec. Fujicolor Pro 400H film rated at 200

LEFT I captured this image as the bride walked to her reception. Lit by skylight at sunset, this composition brings in a nice combination of color and soft light. Contax 645, 80mm lens, ISO 200, f/2 at 1/125 sec. Fujicolor Pro 400H film rated at 200

Sometimes when I photograph people in the shade during a bright time of day, their skin tones turn a little blue. This is caused by light coming directly from the sky, which is so bright and blue at midday. You can also get a green color shift when the sun beats down on the grass, reflecting a greenish hue back on the subjects' faces. The same reflective effect can produce beautiful results if you're

Avoiding Color Shift

photographing on a beach, even on a very bright day. The sand reflects a soft, warm tone that can produce a healthy-looking glow.

However, green and blue aren't flattering hues for most people's skin, so I remedy these color-reflection problems during printing. My printer, Richard Photo Lab, in L.A., reduces the color shift by bringing up an opposite color during processing. Then, when I get the digital scans of the images, I desaturate slightly to remove more of the color. You have to be careful, though, when you remove color shifts through desaturation. If you desaturate too much, the skin tone will turn gray. When you remove the green tint, you can end up with a lot of yellow left in the skin tones, so I desaturate the yellow a little as well, to even things out.

The key is to keep in mind the reflective properties of your surroundings. On a bright day, shooting outside can result in a range of different color reflections in your images. Use them or minimize them according to the look you want. For the fine art look, I often play up the warm tones and minimize the cool tones.

LEFT The cocktail hour is a great time to chat with friends and family you haven't seen in a while—and the drinks are important as well! Colorful detail shots like this make great images for blogs and magazines. Contax 645, 80mm lens, ISO 200, f/2 at 1/500 sec. Fujicolor Pro 400H film rated at 200

BELOW You always want to be careful about reflected colors and color shift, especially when shooting over green or blue surfaces during bright sunlight. This image doesn't have any human subjects, so I didn't have to worry about getting a reflected greenish tint on my clients' skin. By using a shallow depth of field, I was able to focus on the warm tones of the candle without a lot of greenish light bounced from the grass seeping into the exposure. Contax 645, 80mm lens, ISO 200, f/2 at 1/30 sec. Fujicolor Pro 400H film rated at 200

People ask me all the time why I shoot film. Is there really a difference in the images? In my view, yes, and the reason is color. I can't get the same color, with the same consistency, using digital capture. I'm not saying you can't achieve similar results with a digital camera and a firm grasp of Photoshop, but I prefer to do everything in camera, as opposed to running filters and plug-ins later. By shooting film and employing a carefully

Why use film? The reason is COLOR.

The Film Advantage

designed exposure formula, I produce a uniform look across all of my images. That is vital to creating a cohesive collection of art for my clients. Plus, I can spend my time shooting and interacting with clients, as opposed to sitting in front of a computer running image-enhancement effects. I try to avoid my computer unless I'm e-mailing a client, retouching, or designing an album. The rest of the time, I'm out in the world living.

RIGHT Just after the bride finished dressing, I placed her to the left of a window, exposed for the shadow, and had her tilt her head slightly down. When she looked back up at me, I created this portrait. Contax 645, 80mm lens, ISO 200, f/2 at 1/60 sec. Fujicolor Pro 400H film rated at 200

OPPOSITE I framed this image of the bride and groom getting ready to exchange rings in such a way as to include the bride's sister and mother holding hands in the background. Canon EOS-1v, 70–200mm lens, ISO 200, f/2.8 at 1/2000 sec. Fujifilm Neopan 400 film rated at 200

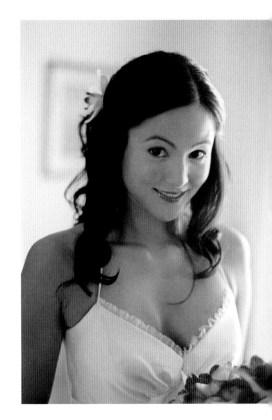

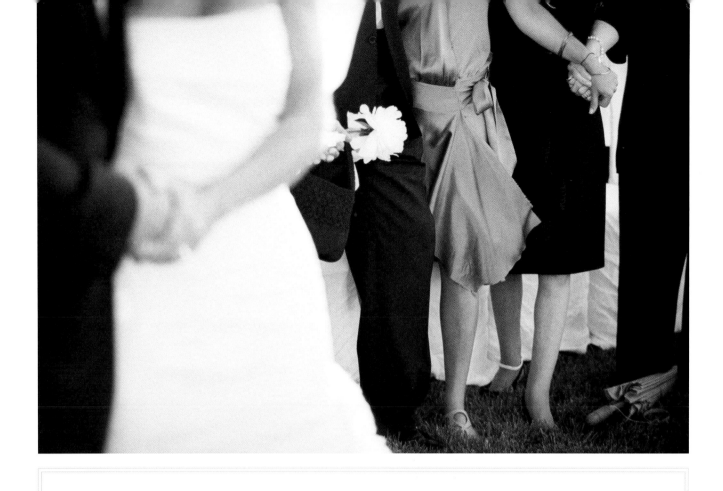

Lesson Learned

Earlier in my career, I shot the wedding of a Korean couple who had an elaborate ceremony full of vibrant colors, including the bride's striking red dress. Unfortunately, the tungsten lighting at the indoor venue was dim and not very attractive. The combination of bad lighting and contrasting colors was bound to wreak havoc on my images and create an awful color shift.

Thinking technically, I opted to shoot the ceremony in black and white. Kodak T-MAX P3200 film lets in a great deal of light and is very forgiving, so I loaded some rolls into my Contax 645 and fired away.

When the film came back and I showed the images to the bride, she freaked. "Didn't you see all the beautiful colors at my wedding?" she cried. "Didn't you see my red dress?" I did, but I'd been looking at everything with tunnel vision, thinking about only the technical aspects and not fully considering what the bride and groom would want. This is a terrible mistake to make at any wedding, much less an elaborate, colorful affair for which the bride and groom had specifically hired me to make an artistic portrayal of their event.

Because I was shooting film, there was no way to convert my images to color. To partially satisfy my clients, I gave them a discount, printed some additional images, and reprinted some others.

It was a bad situation, but something really good came out of it. After that wedding, I opened my eyes to lighting situations and color. I resolved to find ways to portray the full brilliance of a wedding by working with light, manipulating light, and creating light in ways that satisfied both my technical requirements and my clients' wishes. That was what prompted me to start incorporating video light. I taught myself how to work with these low-light situations without flash. I learned to bring in ambient light and work with contrasting colors. Above all else, I made myself think, *What do I need to do so this never happens again?*

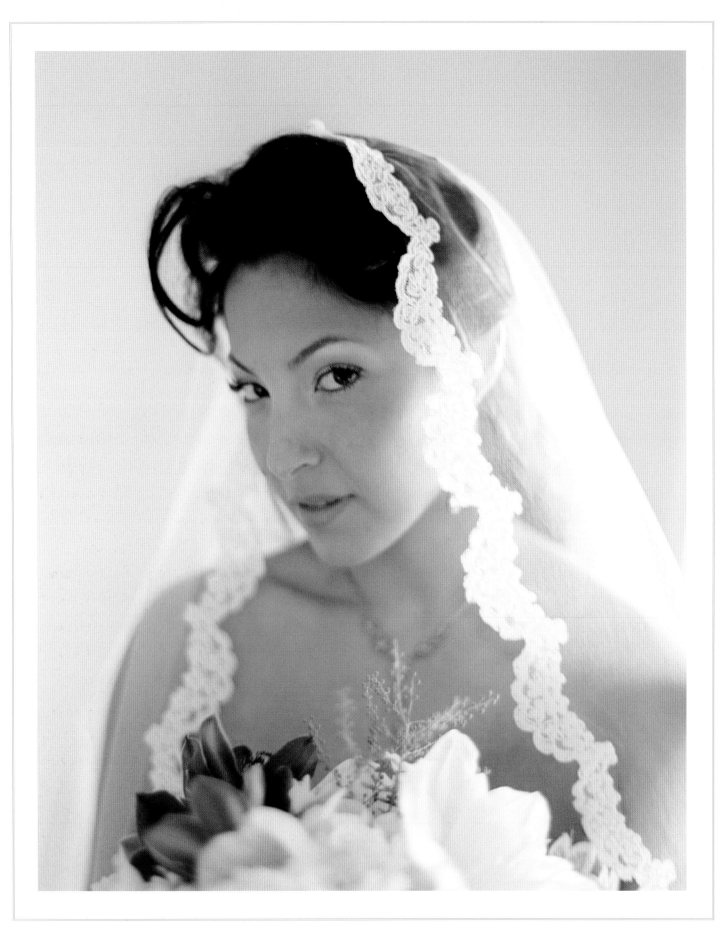

4 Direction

At my workshops, people always ask me about posing. I don't think of it as posing so much as directing—putting people in the right situation and then making images when it feels right. The goal is to create images in which people *don't* look posed, even if the situation has been engineered by the photographer. I'm not a photojournalistic shooter; I do set up images to create better compositions, but always with the goal of creating situations that look natural.

I see portfolios all the time in which the images are so stiff. If you can look at an image and imagine the photographer saying, "Okay, guys, one, two, three," right before he clicks the shutter, then the posing is too static. I want images with a genuine feel.

How do you accomplish that? You have to open up to your clients, find a way to relate to them, build a connection. When you do, you'll create better images, you'll have more fun, and you'll make more money. Yes, good, natural posing boosts sales. When clients *feel* comfortable, they *look* comfortable. When they look comfortable, they look better, and you can bet they're going to buy more of what the photographer is selling.

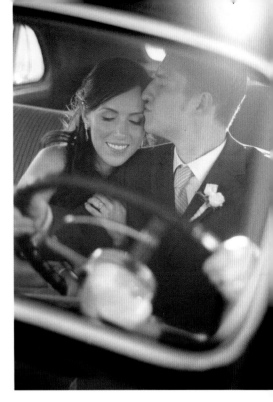

When I meet clients for the first time, I pay a lot of attention to their features. I subtly examine their skin, faces, noses, chins, and mannerisms. I start thinking of how to pose them, how to accentuate their positive features and downplay the features that make them uncomfortable. I also consider lighting and exposure issues that will affect their skin types.

Directing subjects takes practice. It's a particularly tough challenge for

Setting the Scene

new photographers. I certainly had trouble with it when I first started. I was nervous about inserting myself into the process and asking my clients to do things. I didn't want to seem pushy or cheesy, so I tended to remain fairly passive.

Eventually, though, I learned that I needed to get past those feelings of insecurity and give more of myself to my clients. I realized that it's not all about getting the subjects to loosen up; *I* needed to loosen up as well. I needed to do more to help my clients feel more comfortable. I needed to share my knowledge and my ability and encourage them to buy in to the process. If I didn't, then I wasn't providing the best level of service.

During the portraits of the bride and groom, my direction begins with putting my subjects in the right starting position. Think of it like creating a frame for a scene. I find a beautiful setting with the right background and optimal lighting. I consider how the technical elements will come together, adjust my exposure settings, and select the right lens and film. Then I simply put my subjects in the chosen area and let them be. I've already thought about how the lighting will work with their skin, how the backdrop will appear in the final images, and how the full scene will work. So I'm no longer thinking technically at this point. That helps me move on to the next step: getting them

PAGE 52 I photographed this bride in her getting-ready room just minutes before she walked down the aisle. There was window light to camera right, illuminating this small space. Using an off-white wall as backdrop, I placed the bride by the window and exposed for the shadow on her face. I rated my 400-speed film at 200, and then overexposed by a stop to create a warm glow from the window light. Contax 645, 80mm lens, ISO 200, f/2 at 1/500 sec. Fujicolor Pro 400H film, rated at 200

ABOVE With the bride and groom sitting in the vintage car they rented for their wedding, I asked them to just get close and do what comes naturally. As he kissed her forehead, I composed this frame, exposed for the shadow, and let the setting sun backlight the scene. Contax 645, 80mm lens, ISO 200, f/2 at 1/1000 sec. Fujicolor Pro 400H film rated at 200

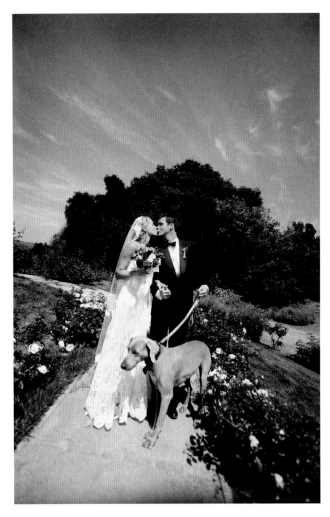

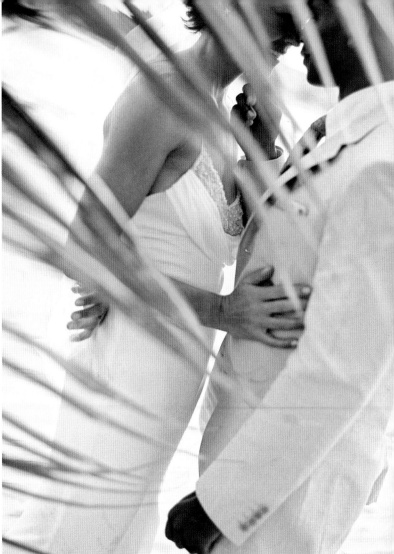

LEFT Directional sunlight was shining on this couple as they walked toward their ceremony with their dog. I asked them to pause and kiss, and then I shot from a low angle to create a striking background of foliage and sky. Canon EOS-1v, 16–35mm lens, ISO 200, f/2.8 at 1/4000 sec. Fujifilm Neopan 400 film rated at 200

ABOVE I pulled this couple away from their guests to shoot a few images along the beach. Focusing through the palm leaves and using skylight from the setting sun to illuminate the scene, I let the couple embrace and relax. Contax 645, 80mm lens, ISO 200, f/2 at 1/125 sec. Fujicolor Pro 400H film, rated at 200

to interact naturally. All I have to worry about is the communication between the bride, the groom, and me.

Every client is different. There are so many emotions going on during a wedding, and each person handles them in his or her own way. During the portraits, some clients aren't even there with me mentally—they're off at the party or thinking about the next part of the day. I have to try to get them away from all that, to embrace this moment away from everyone and just be alone with their new spouse. This is a special time.

Once I get them away from everything, most of my clients will relax and just do their own thing. The excitement of their new marriage sinks in, and they settle down and start being themselves. They hug, they kiss, they lean on each other and giggle. When they interact this way, I'm just there watching and photographing what comes naturally. I don't have to do all that much!

Unfortunately, I can't always get my subjects to just relax, be themselves, and naturally generate great poses. Some couples are just too wound up to relax and interact naturally. Others might be uncomfortable because it's hot where we're shooting, or they're uneasy in front of the camera. In these situations, I have to work on getting them to relax and genuinely communicate. As much as I like

Directing the Portraits

things to happen spontaneously, these are the instances in which I need to insert myself and do some directing. Even in these cases, I try to keep my intervention minimal.

I typically start my directing by placing my subjects in a starting position and then trying to get them to interact from there. I may run through an exercise to get them loosened up. I may talk with them casually and try to take their mind off the craziness of the day. Movement also helps. When I get to a point when something isn't working or the clients are stiffening up, I get everyone up and move them. We go to a different location. We take a little walk. Just changing positions and resetting things can make a huge difference.

When all else fails, I rely on a set of tried-and-true techniques for releasing tension and creating fun, natural images:

ELIMINATE DISTRACTIONS. Get the couple away from other people. During the couple's portraits, I try to eliminate distractions like groomsmen, bridesmaids, family, and other guests. If I have to put the couple in a car and drive them three minutes down the road, I will. It is vitally important to separate them from the frantic energy of the day so they can be themselves.

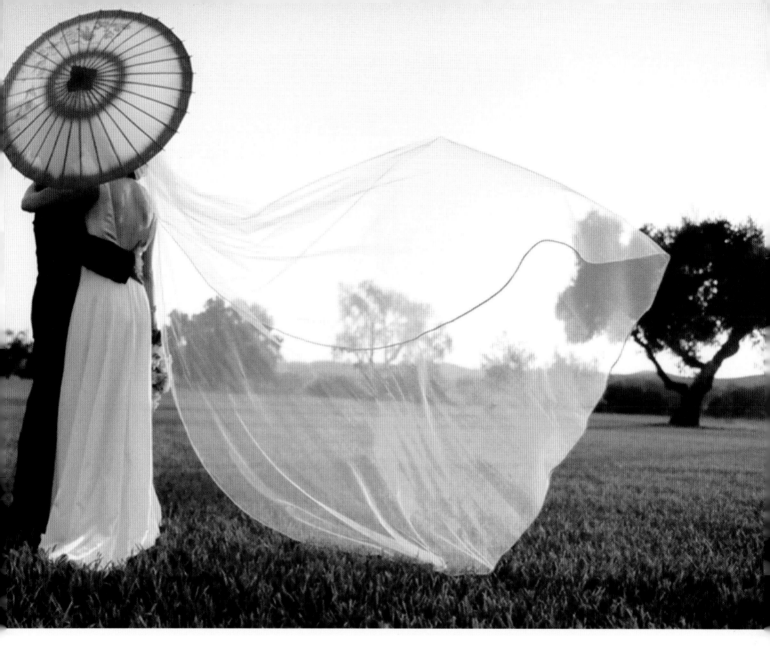

GET A LAUGH. One of my favorite techniques for creating spontaneous, natural-looking images is to ask the bride and groom to close their eyes, lean in, and kiss each other. Because their eyes are closed, they always miss and end up kissing each other's forehead or eye or chin. Inevitably, they crack up, genuinely laughing at themselves, and *that's* the moment I'm looking for.

TAKE A WALK. People get stiff when asked to sit still and pose. I avoid this by having my subjects move around—within my area of favorable light, of course. Often, I'll have the couple hold hands and walk away from me. They might kiss as they walk. They might giggle or just talk. They tend to relax and ease into their natural motions, and that process often leads to great images.

This couple had decorated their reception with these parasols, so we grabbed one for the perfect prop. I asked the bride and groom to face away from me, with the setting sun to their right, and embrace behind the parasol. With the couple in this starting position and perfectly illuminated by the golden sunlight, I let them interact naturally. When they began to kiss, my assistant flipped the bride's veil up in the air and then darted out of the frame just as I clicked the shutter. Canon EOS-1v, 24–70mm lens, ISO 200, f/2.8 at 1/500 sec. Fujicolor Pro 400H film rated at 200

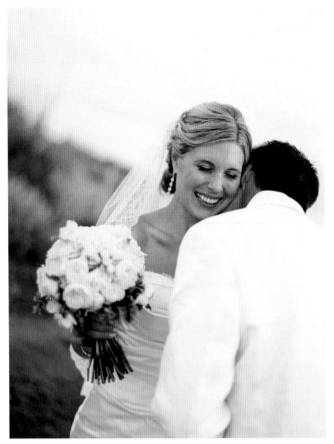

I may also have them walk toward me, especially if we're in a field or an area with tall grass. The groom will usually help the bride negotiate her dress through the tricky terrain, and I can capture wonderful shots of them embracing and holding each other.

MULTITASK DURING A WALK. While we're walking around, I'll have the couple walk toward me, hip to hip, holding hands. I walk backward, moving away from them as I photograph. As we walk, I ask them to lean over and kiss while they're walking. Just like the closed-eyes kiss technique, they're bound to miss each other's lips because of the motion of their strides, and they end up kissing a chin, a cheek, a forehead. Maybe they bump noses and laugh. When this happens, they might get a little embarrassed and look away from the camera or each other. That reaction makes a fantastic image. It's very natural and genuine, which is exactly what I'm looking for.

PUT SOME DISTANCE BETWEEN US. If they are interacting well, I may have the couple continue to walk away from me as

I shoot from afar with a telephoto lens. The farther away they get from me, the more relaxed they tend to become. With some distance, they feel as if no one is watching them or listening to them, and they loosen up and relate to each other naturally. Meanwhile, I can capture some great images of them laughing and embracing in a natural scene.

The same principle applies to images in which there's a physical barrier, like a window or partial wall. Sometimes I'll ask couples to sit in their getaway car and work from outside the car. The little bit of a barrier helps them feel more secluded, and they often relax.

STROLL DOWN MEMORY LANE. I often ask the bride and the groom to tell me something about the other one. Couples love to reminisce and talk about how they fell in love. I may prompt them to talk about the goofy stunts they each pulled while they were dating or tell me funny stories from their past. These conversations always get them laughing and smiling as they talk about the things they love about each other.

PROP IT UP. Just because we're at a wedding, that doesn't mean we can't throw some props into the portraits. For example, if a bride has a parasol or the groom has a hat or if there is a cool decorative item at the wedding, then I love to incorporate it into the portraits.

Having a prop to play with tends to loosen people up because they are focused on their interactions with the prop and each other and not nervous about the photographs. Plus, it brings something special from their wedding design into the portraits. I did one wedding for a fellow photographer for which we incorporated vintage cameras that she used to decorate the reception. I worked another event at which the couple rented a classic car, and we drove through some nearby fields with the car and captured a set of amazing portraits.

As much as I love working with props, I don't bring my own. Props should be something personal to the couple, not a tacky set of toys I haul around in the back of my car.

OPPOSITE Working with the bride and groom at sunset by the beach, I asked the groom to kiss his bride on the neck. She laughed, which helped break up the nervousness and make them less camera shy. Contax 645, 80mm lens, ISO 200, f/2 at 1/250 sec. Fujicolor Pro 400H film rated at 200

OPPOSITE RIGHT This wedding featured large pieces of candy at the table settings, so I asked the bride to hold one in front of her face and look away. Right at sunset, the surrounding lights came on around this venue, creating a perfect backdrop for the portrait. Contax 645, 80mm lens, ISO 200, f/2 at 1/30 sec. Fujicolor Pro 400H film rated at 200

ABOVE Shooting at a wide angle with my 16–35mm lens, I asked the groom to kiss the bride on the cheek. She closed her eyes as he leaned in, and I made this portrait. Canon EOS-1v, 16–35mm lens, ISO 200, f/2.8 at 1/60 sec. Fujifilm Neopan 400 film rated at 200

Having a prop
to play with
tends to loosen
people up
because they
are focused on
their interactions
with the prop
and not so
nervous about
the photographs.

ABOVE Props are always fun at a wedding, so when the bride and groom wanted this photograph with their sign reading FOR ALL MY DAYS, I posed them with sunset light backlighting them and asked them to lean in, close their eyes, and kiss. Contax 645, 80mm lens, ISO 200, f/2 at 1/125 sec. Fujicolor Pro 400H film rated at 200

OPPOSITE LEFT As we walked down the steep rock stairs, the groom helped his bride navigate the uneven terrain. It was a very foggy day in the mountains of Monterrey, Mexico, and the diffused light allowed me the freedom to shoot comfortably as the couple walked toward me. Contax 645, 80mm lens, ISO 200, f/2 at 1/60 sec. Fujicolor Pro 400H film rated at 200

OPPOSITE RIGHT Holding a parasol and posing beneath the archway, the bride and groom laughed at my silly remarks about the groom being "Mr. Tough." That was enough to draw a smile from both of them, and I captured this image. Contax 645, 80mm lens, ISO 200, f/2 at 1/250 sec. Fujicolor Pro 400H film rated at 200

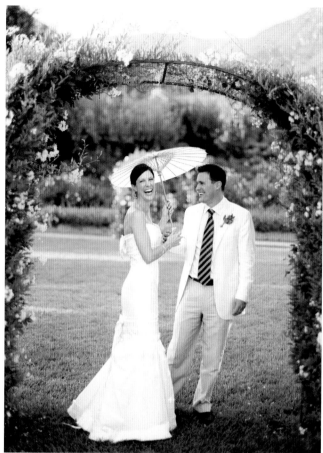

Lesson Learned

When photojournalism was the style du jour, I had a lot of brides call me and ask if I was a wedding photojournalist. These brides had been coached by the bridal magazines to ask their photographers certain questions, and one of them was about photojournalism. This was earlier in my career, and I wanted the work, so I'd say, "I don't know. I guess I am," because that was the only way they would hire me.

Unfortunately, the concept behind photojournalism meant that I wasn't supposed to pose anything. These couples expected me to just float around and document with zero interaction.

So I tried to be a fly on the wall and nothing more. I just documented. When I'd look at the proofs from those weddings, I was always disappointed. With a little bit of direction, I could have made the clients look so much better. I could have created better images and sold more products.

I quickly learned that the most important thing isn't conforming to the current trend but rather being true to myself. When I was trying to be a photojournalist, I wasn't following my artistic inspirations. The images weren't as good. My clients weren't as happy. I wasn't as happy.

So I started to insert myself more. I really believe that's what clients want. They want you to help them look better. They want you to encourage them. They want you to maximize their experience rather than just be a bystander. They want you to show them that you are putting some artistry into the work, as opposed to just snapping pictures. It's a matter of service. That's the difference between a high-end operation and just some guy with a camera.

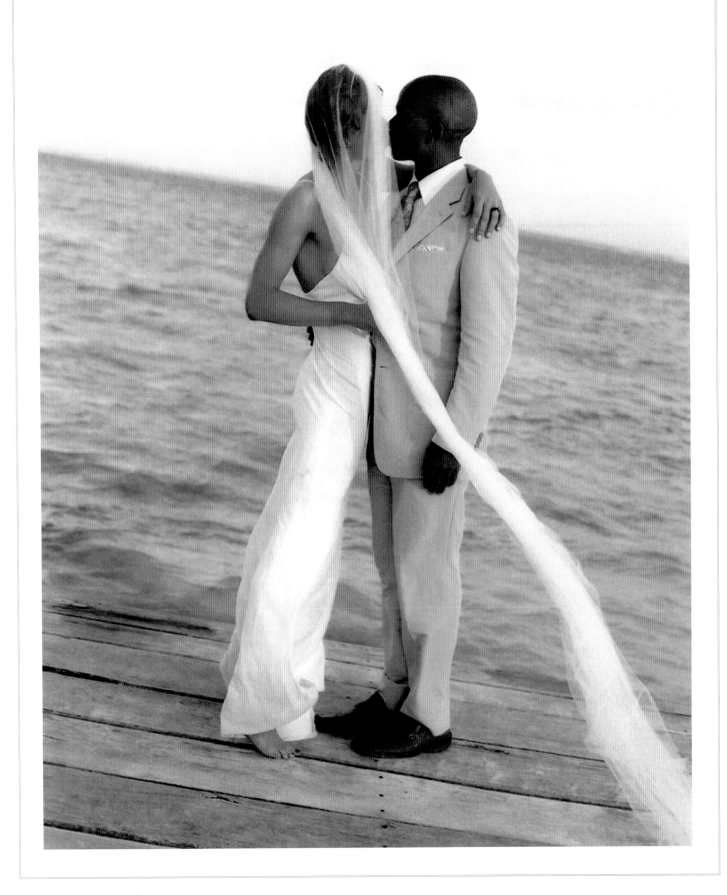

5 Composition

People ask me all the time, "Why am I attracted to this photograph?" My answer is often that the appeal of an image may not have anything to do with its subject but rather with how the image is presented within the frame. That certain something that people just can't put their finger on, that X factor, is composition.

The key to composing in the fine art style is to think of all your picture elements working collaboratively. Good composition isn't just about where you place your subjects in the frame or how much background you allow to show. It's also about angle, color, focus, distance, exposure, light, mood, and content. It's about camera and lens choice. It's about how your subjects are moving in relation to you. Composition is about putting everything together in one frame for an idealized capture.

It sounds complicated, but it's really not. The important thing is to consider your design aesthetic ahead of time and then shoot with a consistent vision in mind. I want all of my images to look clean and simple. I keep this aesthetic consistent, which makes designing albums easier and gives all of my work a cohesive feel.

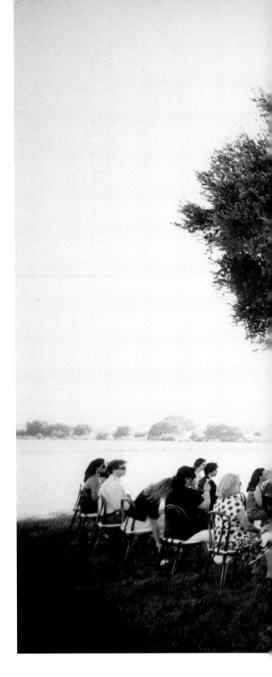

Throughout the day, I adhere to the following composition principles:

* Create a clean canvas.
* Crop in camera.
* Use the rule of thirds.

Crafting a Clean Canvas

My aesthetic revolves around simplicity. I try to eliminate distractions that divert the viewer's attention from the point of interest. It's all about creating a beautiful canvas and then placing my subjects within it.

The starting place is a clean, consistent backdrop, ideally with light colors. I use a lot of walls in my compositions, as well as natural scenes and the sky. I want to put my subjects in front of something that will let the other elements of my photography shine.

If distracting elements exist, I physically remove them. If I can't remove them, then I crop them out in camera. If I can't crop them, I use a shallow depth of field to minimize them. I always shoot at low f-stops, so my backgrounds are typically blurred. Often it doesn't necessarily matter what specific items are in the background, as long as they blur together to form a smooth canvas.

I'm always careful to avoid "black holes"—dark objects in a background that turn into distracting black blemishes against the lighter, softer elements. If everything else is light and airy, a dark object will draw the viewer's eye immediately. Since I use a lot of selective focus with soft-focused backgrounds, anything from a dark mailbox to a dark car could blur into a distracting black hole. If I see a potential black hole in my background, I remove it or shift the orientation of the shot to eliminate it from the frame.

Three Rules of Thumb

fine art wedding photography

PAGE 62 The wind had just picked up as I captured this image on a small island in Belize. The bride and groom were lit by only the sky, with no directional light, so I shot freely from a variety of angles until I came across this composition. Contax 645, 80mm lens, ISO 200, f/2 at 1/500 sec. Fujicolor Pro 400H film rated at 200

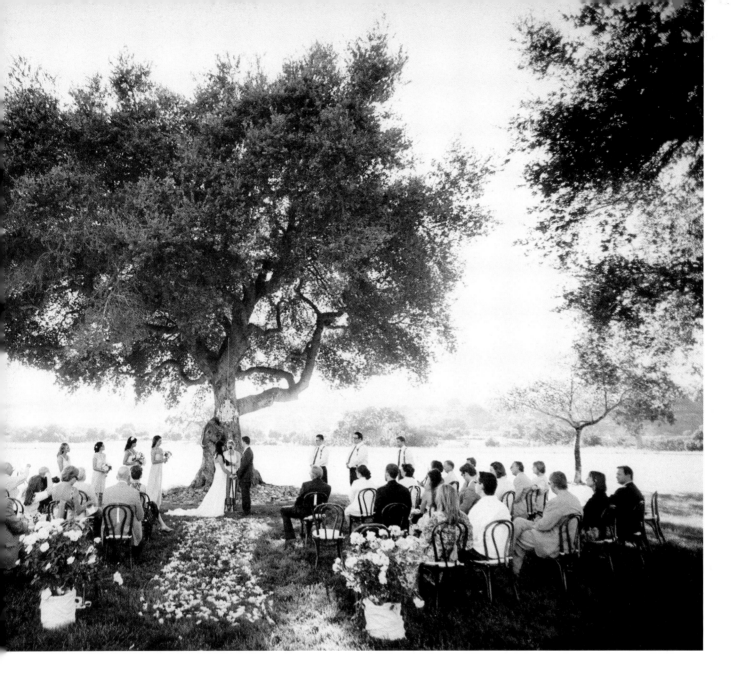

Cropping In Camera

I rarely crop images in postproduction. My goal is to choose the right lens for every shot so that I get the composition right in the camera and don't need to crop later. To help this process, I'm always thinking of the different lenses that I can use. Different lenses have different focal lengths, which I use as tools to affect my backdrop.

Changing lenses, and sometimes cameras, is critical. When working with my Canon SLR, I'll often switch between a telephoto and a wide angle for different views of the ceremony. With my Contax, I'll move in and out to get the right composition with my 80mm fixed lens.

ABOVE Working from the back of this scene, I captured this wide-angle shot with the people in the lower third of the frame. The composition draws interest to the background and natural elements, as well as to the wedding party. Canon EOS-1v, 70–200mm lens, ISO 200, f/2.8 at 1/2000 sec. Fujifilm Neopan 400 film rated at 200

The Rule of Thirds

I use the rule of thirds in many of my compositions. Centrally oriented shots can be great, but I often find that the composition is more interesting when the subjects are offset, allowing different colors and dimension to come into the frame.

The rule of thirds is a compositional guideline that breaks down images into thirds, both vertically and horizontally. To divide the composition, imagine the frame broken up into sections by two equally spaced horizontal lines and two equally spaced vertical lines. The idea is to place important compositional elements along these lines or their intersections. Doing so injects more energy and interest into your compositions than would centering the subject. For example, you can try to position your subject's body along one of the vertical lines and the person's eyes on one of the horizontal lines.

The rule of thirds applies to background elements as well as to the main subject. You can place items like the horizon, trees, and buildings along the guidelines to create more interesting compositions. I try to avoid creating compositions in which the subject is at dead center and the horizon line crosses the frame straight through the middle. Of course, you don't need to line everything up exactly on one of the lines. I like to play around with my compositions to find the optimal combination of subject, background, lighting, and color. My compositions often crop out parts of people to accentuate the point of interest.

RIGHT In another sky-backdrop image, I posed this couple underneath a 14-foot cross on the beach in Acapulco. Shooting at 1/8 second, I held my breath to minimize camera shake. Canon EOS-1v, 24–70mm lens, ISO 200, f/2.8 at 1/8 sec. Fujicolor Pro 400H film rated at 200

OPPOSITE I composed this image by shooting over the groom's shoulder to capture the bride's expression. The composition takes advantage of sunset backlighting on the bride while displaying the intimacy of their embrace. The leaves in soft focus draw the eye down to the subjects' faces, while the pastel colors on the wall behind them form a clean backdrop in my preferred color palette. Contax 645, 80mm lens, ISO 200, f/2 at 1/60 sec. Fujicolor Pro 400H film rated at 200

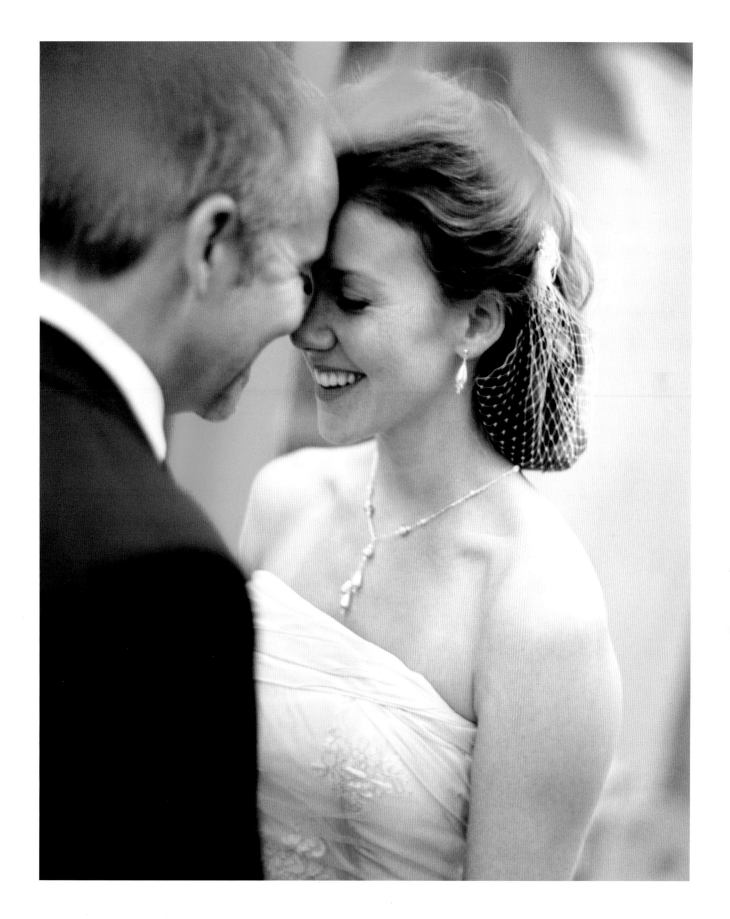

When working with the bride and groom on their portraits, I have the most control. This is when I'll be most creative with my compositions: I'll move them around, I'll use different backdrops, I'll employ bushes and churches and buses and cars to frame the subjects.

But not all parts of the day are this easy. In many instances, I have to deal with the situation I've been given, although I'm not afraid to step in and

Composing the Stages of the Day

tweak certain situations in the name of better composition. For example, I might ask the couple to shift their position slightly as they cut the cake so that I can direct the ideal image.

The time when I have the least control over composition is during the wedding ceremony. The ceremony is where your vision will really be put to the test. But you don't have to settle for the scene exactly as it's given to you. To accomplish the compositions I want, I move. If I can't move my subjects, I move myself. There is always another angle, another viewpoint that I can achieve to get the look I want. My tendency to crop in camera proves quite useful during the ceremony, as I'm able to accentuate certain elements of the frame to capture emotions and expressions.

When I was just getting started, I didn't pay attention to design. I just shot images, going for what moved me at the time. Then, when putting together albums, I would kick myself. As I designed the books, I'd think, *I should have shot this image differently so it matched the others*, or *I should have kept the compositions consistent from one scene to the next*. Now I don't have those moments of frustration because I've predesigned everything in my head. I emphasize consistency in composition so everything works

together and one page of an album goes well with the next.

As with every other element, consistency is critical to composition. I want to vary my images, giving my clients different looks and compositions, but I also want everything to look like it came from the same artist. That consistency is what helps you establish a trademark look and feel and send you on your way to the next level of the wedding photography business.

So my suggestion is to be your own art director. Play with your compositions to establish your own look and feel, and then craft a consistent look that is all you.

At the exact moment the groomsmen looked at the bride and groom as they exchanged rings, I zeroed in with my 70–200mm telephoto lens and angled my camera to create the linear nature of the image. Canon EOS-1v, 70–200mm lens, ISO 200, f/2.8 at 1/250 sec. Fujifilm Neopan 400 film rated at 200

My compositions often crop out
parts of people to accentuate
the point of interest.

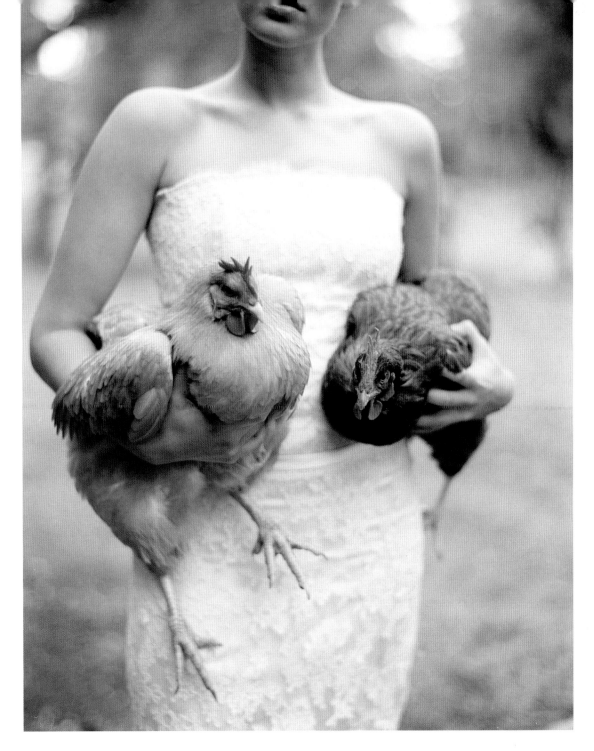

OPPOSITE TOP A flower girl helped the bride with her dress as they walked to the ceremony location. Backlighting with directional sunlight, I exposed for the shadow to capture detail in the white fabric of the bride's and flower girl's dresses. Canon EOS-1v, 24–70mm lens, ISO 200, f/2.8 at 1/125 sec. Fujicolor Pro 400H film rated at 200

OPPOSITE BOTTOM I asked the aunt of the bride to look down as I shot from above under skylight. I exposed for the shadow on her skin to bring out the detail in the shaded areas while producing definition in her dark-colored outfit. Contax 645, 80mm lens, ISO 200, f/2 at 1/250 sec. Fujifilm Neopan 400 film rated at 200

ABOVE For a fun shot, the bride held two chickens as we walked to our chosen location for her main bridal portrait session. I cropped the image in camera to keep the center of attention on the birds, while still including the bride's elegant jawline. I backlit my subject with diffused sunlight shining through the trees. Contax 645, 80mm lens, ISO 200, f/2 at 1/250 sec. Fujicolor Pro 400H film rated at 200

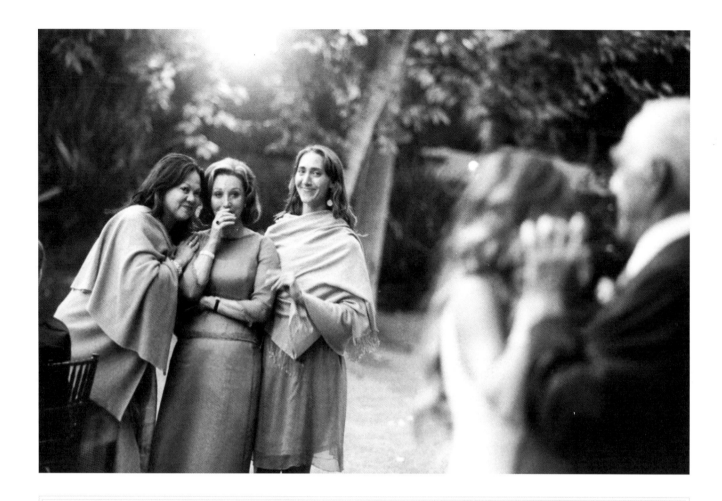

Lesson Learned

I began my penchant for employing the sky as a backdrop early in my career, almost by accident. When I was starting out, I did much more modest weddings that weren't budgeted for the phenomenal venues I often work at today. At these weddings, our bridal portraits often took place in busy public spaces—parks, beaches, cityscapes. So I had to come up with a way to eliminate all the distractions and make the images just about the bride and groom.

One day, while photographing a couple on a crowded beach, I was having a hard time separating my clients from the hundreds of nearby beachgoers. They didn't want to remember their wedding day with all these random sunbathers lounging in the background! The bride kept asking me what I wanted them to do, and I wasn't quite sure. The scene was getting more and more hectic, so I asked myself, *What am I going to do to get all these people out of my clients' wedding portraits?*

Then it came to me: Zoom in close, shoot from a low angle, use the sky as a backdrop, and crop out everything else. I had the couple stand in the sand with an uninterrupted blue sky behind them, and then I zoomed in with my 16–35mm lens. Usually when I use this lens, I focus at 16mm to bring in more of the background, but this time I zoomed in all the way to 35mm to crop out the distractions. I cut out everything in the frame except the bride, the groom, and miles of clear blue sky. Looking at the image, you'd never know they weren't standing on a deserted beach in some exotic, remote destination.

From then on, using the sky became one of my staple techniques. In fact, I crafted a nearly identical composition just a few months ago. In this image, there's a huge housing complex just off the right side of the frame. But by zooming in close with my 70–200mm, I made the image all about the couple and nothing else.

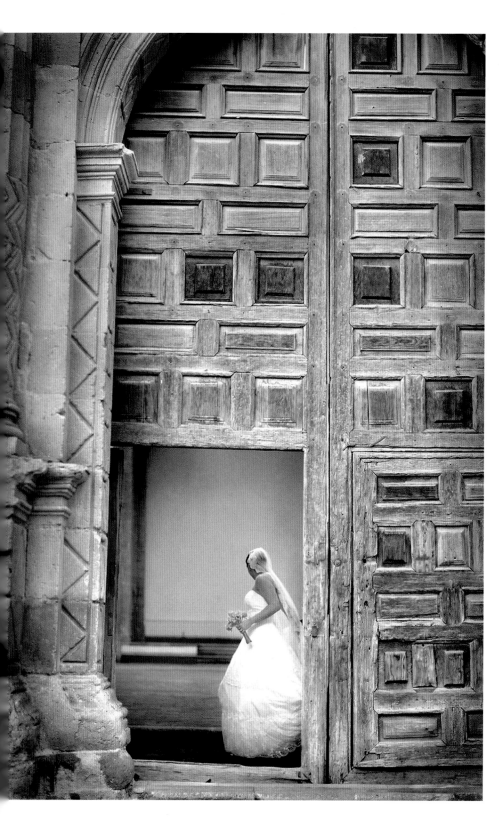

OPPOSITE The emotion was apparent as the mother of the bride and her two friends looked on at the bride dancing with her father. By maneuvering around behind the bride and her father, I composed the shot so that the mother and her friends were the focal point and backlit by the setting sun. My wide open aperture put the bride and her dad in soft focus, further accentuating the emotions on the faces of the three women. The bit of flare comes from shooting directly into the sun. Canon EOS-1v, 70–200mm lens, ISO 200, f/2.8 at 1/60 sec. Fujifilm Neopan 400 film rated at 200

LEFT This composition highlights the patterns in the old wooden door while drawing your eye to the lower portion of the frame where the bride appears. By photographing the bride on the right side of the door opening, with the majority of the door space in front of her, in the direction she is walking, there is a sense of implied motion as she moves forward into the open space. Contax 645, 80mm lens, ISO 200, f/2 at 1/125 sec. Fujifilm Neopan 400 film rated at 200

part

2 of

the
stages

the
day

The fine art approach relies on consistency throughout the wedding experience, and this process is most important on the actual wedding day. The shooting techniques may vary slightly as the day proceeds, but the underlying principles remain the same. The goal is to create a process that—from the clients' perspective—is consistently high-end, reliable, and of the highest quality.

I placed the bride's dress and her bridesmaids' dresses on the curtain rod, backlit the scene, and exposed for the shadow. Even with the dresses and curtains blocking the direct sunlight, it was a bright scene, so I exposed for 1/1000 second to bring in just the right amount of warm glow without washing out the scene. Canon EOS-1v, 16–35mm lens, ISO 200, f/2.8 at 1/1000 sec. Fujicolor Pro 400H film rated at 200

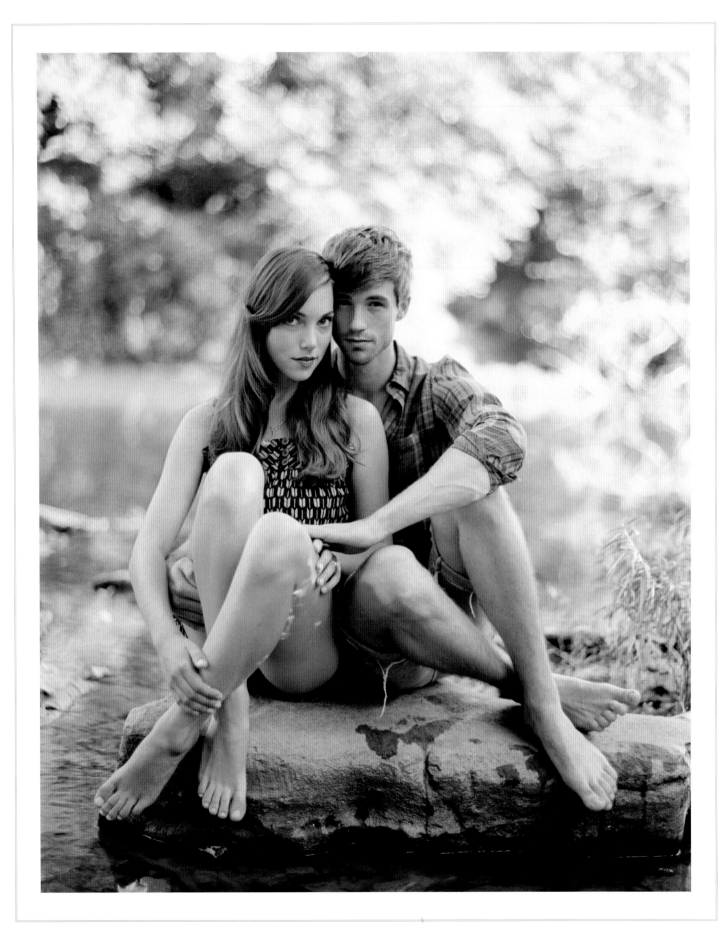

6 Engagement Sessions

Over the years, I've really grown to love engagement sessions. They're a great way to get to know your clients, set the stage for the big day, and make a little extra money. Most important, I get to familiarize my clients with my working style prior to the wedding. If I'm going to clash with my clients over the way I work, it's best to figure that out prior to the event. You don't want conflict once the wheels of the wedding have started rolling. After all, you can redo an engagement shoot if things go horribly—or just terminate the photographer-client arrangement altogether—but you can't jump ship once you're at the wedding. There are no do-overs at that point!

Engagement sessions are becoming a bigger and bigger part of this business, as couples are paying more attention to the role of the images in their overall wedding experience. I've had couples do their engagement sessions in a particular theme—perhaps a vintage look—and then echo that theme throughout all their wedding materials, including the save-the-date cards, the invitations, and the decorations at the wedding reception.

My clients are also buying more products from engagement sessions than ever before. Clients receive about 125 images as loose prints, but many purchase larger matted prints for display at their wedding reception or in their homes. People are also buying albums just of their engagement images. These days, a lot of clients buy an 8 x 8 album of their engagement portraits and then follow that up with a 12 x 12 album of their wedding images. So there's a nice consistency in the pieces and a healthy profit from the additional album sales.

I approach my engagement shoots in a nontraditional way, treating them like editorial photo shoots complete with styling, makeup, maybe even a theme. We style these "ordinary" people like they're models, put them into scenes, and just have fun. For many of these sessions, I bring in a makeup artist and hair stylist, and we integrate the couples' outfits and appearance with the theme of the shoot. For example, if we're photographing with a vintage car, we might style them with a more retro look. If we're riding horses on the beach in Mexico, we do a casual, summertime look.

My engagement sessions usually take between an hour and a half and two hours. I conduct them near my studio in Santa Barbara County, unless the clients want to pay me a travel fee to go elsewhere. I don't charge a sitting fee to wedding clients because that's wrapped into their wedding package. I have some clients call and hire me just for an engagement session because they can't afford my full services for their wedding. This sort of session has become a little business unto itself.

Engagement portraits are useful to me for promotion, as they are gaining traction in publications and the blog world. People are no longer just showcasing weddings; they're showcasing engagements as well.

All these fringe benefits are fantastic, but for me the most critical advantage of an engagement session is that it allows my clients to understand my work and my process. They know what to expect from my shooting techniques. They see how I employ color. They witness how I use black and white. They establish a feel for my style and start to develop a sense of the types of images they want for their wedding day. Building the foundation for a great working relationship is priceless.

ENGAGEMENT SESSION BASICS

CAMERA: Contax 645 and Canon EOS-1v 35mm SLR with lens

LENS: For Contax, Carl Zeiss 80mm F2; For Canon, Canon 50mm F1.2

FILM: Fujicolor Pro400H and Fujifilm Neopan 400 rated at ISO 200

EXPOSURE: Aperture Priority set to the max aperture of the lens (f/2 for the Zeiss, f/1.2 for the Canon).

LIGHT: Ambient

LIGHT METER: Sektonic Flash Master L-358 when necessary

PAGE 76 Cuddling on a rock in the middle of a river, this couple posed in the shade of a tree. The casual, country styling is part of the theme of the shoot. It played well with their outdoor wedding. Contax 645, 80mm lens, ISO 200, f/2 at 1/500 sec. Fujicolor Pro 400H film rated at 200

OPPOSITE I placed this couple by the large window to get some nice soft light on the bride-to-be's face. Exposing for the shadow with a wide aperture, I let the light on the left side of the frame soften the edges of her hair and provide a warm glow that moves across the image from right to left. Contax 645, 80mm lens, ISO 200, f/2 at 1/30 sec. Fujicolor Pro 400H film rated at 200

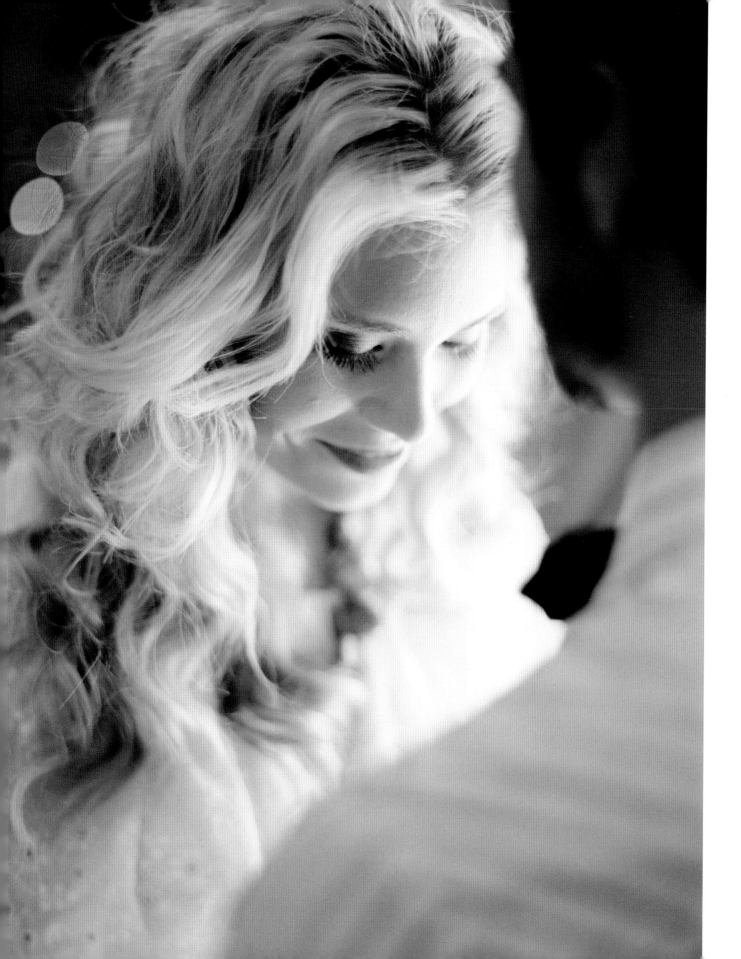

ABOVE As the couple shared a moment in the back of the vintage car, I shot with a very shallow depth of field to play up the romantic feel of this tightly composed image. The styling of the couple lent an old-school elegance to the shoot. Canon EOS-1v, 50mm lens, ISO 200, f/1.2 at 1/2000 sec. Fujifilm Neopan 400 film rated at 200

OPPOSITE BELOW The couple shared a moment as they think about the rope swing they're about to jump onto. The light was diffused by the trees in front of them, creating an ideal situation for a portrait shot with an open aperture and relatively slow shutter speed. Contax 645, 80mm lens, ISO 200, f/2 at 1/60 sec. Fujicolor Pro 400H film rated at 200

Engagement sessions are becoming a bigger and bigger part of this business, as couples pay more attention to the role of images in their overall wedding experience.

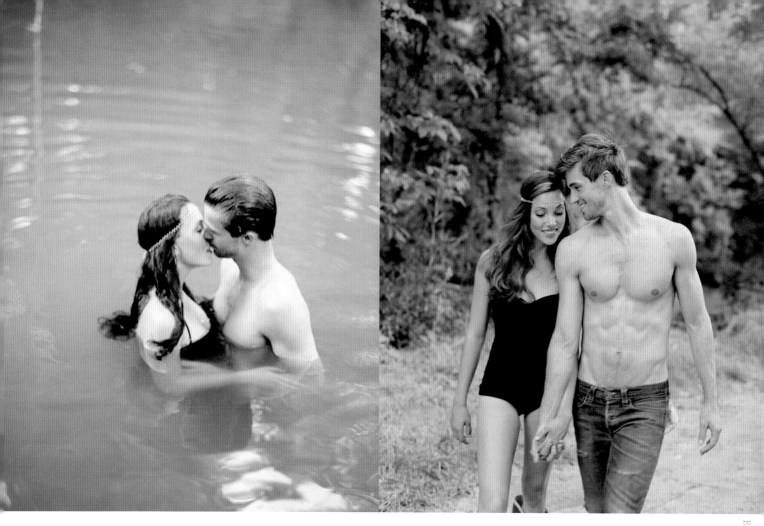

ABOVE LEFT The couple kissed after they jumped into the river. With sunlight diffusing through the leaves of the nearby trees, the greenish hues came out well in this composition, shot at a slow shutter speed and wide-open aperture. Contax 645, 80mm lens, ISO 200, f/2 at 1/8 sec. Fujicolor Pro 400H film rated at 200

ABOVE RIGHT Lit by diffused skylight, the couple walked to their car after jumping into a river. Walking backward, I photographed them as they approached me, backlighting my subjects with the light that filtered through the trees. Contax 645, 80mm lens, ISO 200, f/2 at 1/60 sec. Fujicolor Pro 400H film rated at 200

OPPOSITE RIGHT During their engagement session, this couple enjoyed a laugh on the small step outside an old hacienda. Contax 645, 80mm lens, ISO 200, f/2 at 1/500 sec. Fujicolor Pro 400H film rated at 200

ABOVE I told this couple to sit hip to hip with their knees square. The posing and setting worked well with the styling of the couple—a slightly retro look with the groom's bow tie and bride's sundress and flower. I offset the background elements just a bit to provide some graphical interest and intentional imbalance to the composition. Contax 645, 80mm lens, ISO 200, f/2 at 1/250 sec. Fujicolor Pro 400H film rated at 200

RIGHT Backlighting my subjects with the setting sun, I used an open aperture to put the foreground elements (horse's neck and head) and background into soft focus, while the emotional connection between the couple is clearly portrayed. Contax 645, 80mm lens, ISO 200, f/2 at 1/125 sec. Fujicolor Pro 400H film rated at 200

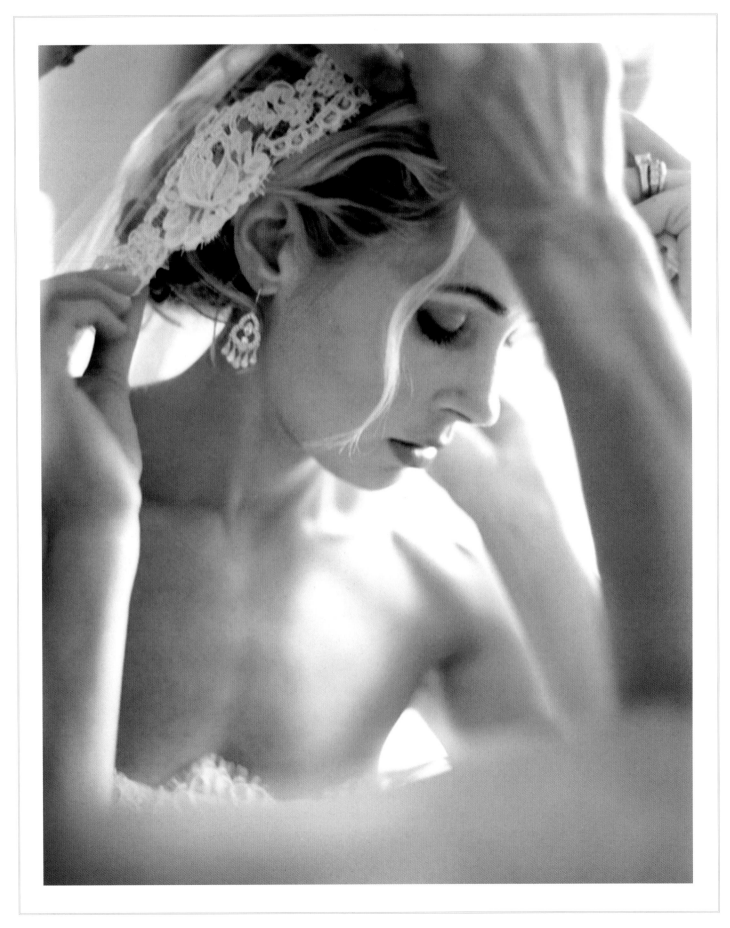

7 Getting Ready

The "getting ready" portion of the day is crucial to setting up the rest of the wedding, both in terms of your interactions with your client and in terms of your photographic coverage of the event. While everyone is getting ready, there is a nervous energy. The clock is ticking. People can be a little on edge. It's important that you don't upset your clients by being too demanding. I try to ease myself into the situation, capture some scene-setting images, and set a fun, collaborative tone for the rest of the day. If I do this successfully, we'll have a great day and make some wonderful photographs. If I don't, it will be a looooong day.

I usually arrive at a wedding a half hour to an hour before I'm scheduled to start shooting. I like to collect my thoughts and think about the day before I begin working. If I haven't been to the location before, I get there a minimum of an hour early to scout it out, mentally prepare, and think about lighting. If I've been there before, I'll usually get there closer to half an hour early.

I usually start with the bride first. When I arrive at the spot where she's getting ready, I immediately introduce myself and my assistant to everyone present. I want them to be comfortable with both of us.

While the bride and her bridesmaids are doing their hair and makeup, I spend a few minutes photographing the dress, accessories, and other details. I don't just shoot things as they are. After asking permission, I move items around to create photogenic scenes. I hang the dress by a window. I arrange the shoes in an interesting composition. I move around jewelry and accessories to create attractive still lifes. And, of course, I am building all of these compositions in ideal lighting situations, usually by some window light or another soft, diffused light source.

In most cases, I have met with my clients prior to their wedding day, and we have already established a good rapport. So during the getting-ready stage, there isn't a lot of interaction. I usually meet the bride where she is getting ready and suggest a few things. If the lighting isn't great on her face, then I'll suggest a change. Once I have her in the right light, I'll start moving items in the background so that I can keep my subject in good light while maintaining a nice, clean background. I don't talk much during this time. I just load film, get things ready, and stay out of the way. I don't want to disturb the makeup artist or the other people in the room.

Once she's situated in the better lighting scenario, I step out while she dresses, asking her to call me when she's ready for the last zip-up shots and the putting on of the veil. When I come back in, since the bride has already been placed in a good lighting situation, I can just start shooting. For these getting-ready shots, I go for the timeless feel of black and white. I shoot wide open with my Contax 645 and 80mm lens set at f/2. I usually shoot for ten minutes, making sure to capture all the critical dressing-room shots, including some portraits of the bride with her bouquet.

When she's in her gown, I'll suggest a place for formal bridal portraits. I usually try to capture these images near a window or some other soft natural light source. I'll direct more during this phase, working with the bride to create some artistic portraits.

The process is similar with the groom. I tend to let the getting-ready stage unfold on its own with little intervention. Just a little tweaking here and there to put my subject in the right light.

PAGE 84 With some assistance from her mom and two bridesmaids, the bride put on her veil. I used the arms of the women helping the bride put on her veil to frame my focal point, the bride's head and face, and then exposed for the shadow on the side of her face. Contax 645, 80mm lens, ISO 200, f/2 at 1/500 sec. Fujifilm Neopan 400 film rated at 200

GETTING READY BASICS

CAMERA: Contax 645

LENS: Carl Zeiss 80mm F2 lens

FILM: Kodak T-MAX P3200 rated at ISO 1600; Fujifilm Neopan 400 rated at ISO 200; Fujicolor Pro 400H rated at ISO 200

EXPOSURE: Aperture Priority set at f/2

LIGHT: Ambient

LIGHT METER: Sekonic Flash Master L-358 when necessary

ABOVE Using window light, I aimed my very shallow depth of field on the toes of the shoes and the plates, letting the pastel colors of the wall and posts form a soft background that almost looks like a painted backdrop. Contax 645, 80mm lens, ISO 200, f/2 at 1/250 sec. Fujicolor Pro 400H film rated at 200

OPPOSITE RIGHT Window light from the left illuminated this scene, and the mirror provided interest to the composition by bringing in complementary colors from the opposite wall. Contax 645, 80mm lens, ISO 200, f/2 at 1/250 sec. Fujicolor Pro 400H film rated at 200

The "getting ready" portion of the day is crucial to setting up the rest of the wedding.

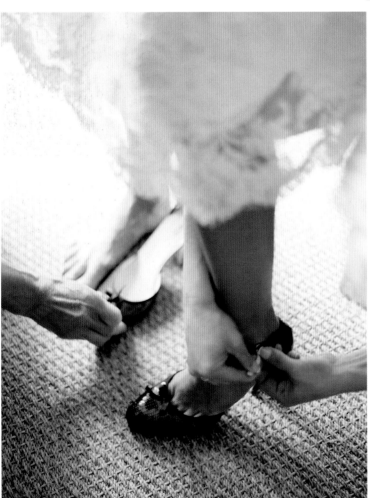

ABOVE The bride looked down as she put on her shoes. I swung around so that she was backlit by window light, and then I exposed for the shadow. My open aperture created a shallow depth of field that highlighted her face and blurred the white dress, veil, and background to produce a light-filled image. Contax 645, 80mm lens, ISO 200, f/2 at 1/125 sec. Fujicolor Pro 400H film rated at 200

LEFT Her mother and sister helped the bride get her shoes on right before she walked down the aisle. With window light filtering in from behind the bride and backlighting the scene, I exposed for the shadow and shot with a slow shutter speed to bring in a soft glow to the image. Contax 645, 80mm lens, ISO 200, f/2 at 1/15 sec. Fujicolor Pro 400H film rated at 200

ABOVE The scene was illuminated by soft window light from the right. I exposed for the shadow and composed the scene to capture the mirror image of the bride as well as her back. This way, I depicted both her face and the detailing in her hair and on the back of her dress. Canon EOS-1v, 16–35mm lens, ISO 200, f/2.8 at 1/500 sec. Fujifilm Neopan 400 film rated at 200

LEFT This getting-ready detail shot shows the bride's shoes and her birdcage veil. I had to be careful with my overexposure technique here because too much overexposure would wash out the detail in the veil and floral accessory. So I worked with a little faster shutter speed than normal to make sure I was capturing all the critical detail. Contax 645, 80mm lens, ISO 200, f/2 at 1/2000 sec. Fujicolor Pro 400H film rated at 200

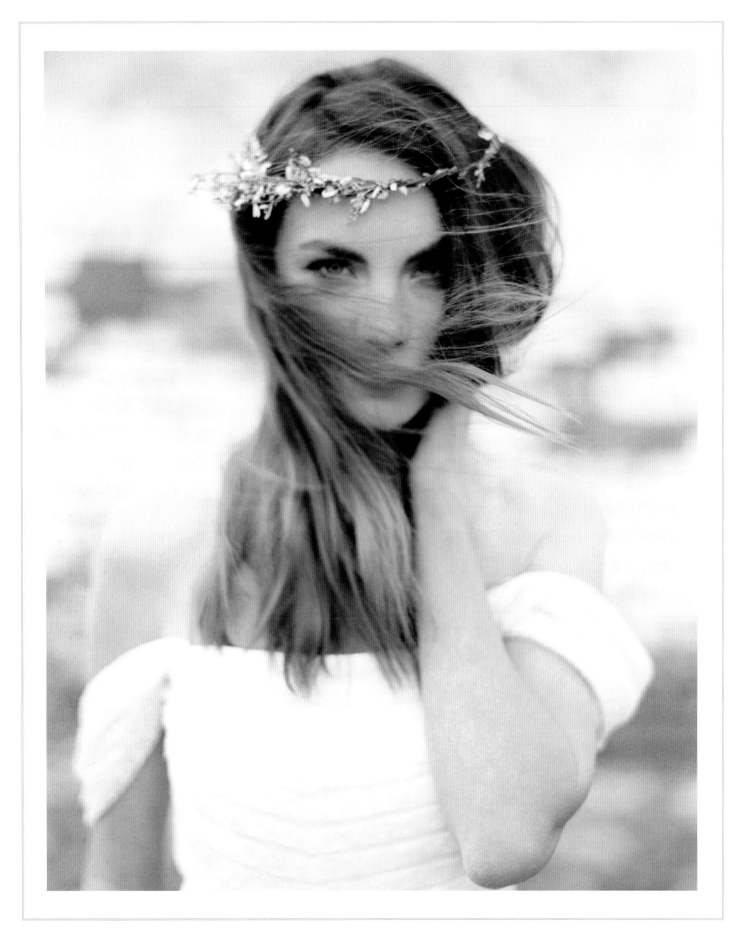

8 Bridal Portraits

Every wedding is scheduled differently. Some brides and grooms will see each other before the ceremony, and some won't. In a typical situation, I photograph the bride, bridesmaids, and the bride's immediate family before the ceremony. I have a scouted location for these portraits, and I work quickly through the combinations to keep everything on schedule.

When working inside, I make sure I'm by a window to let in some natural light. Tungsten lighting shifts the color on film, so I try to use as much natural light as possible. If there's a decent-sized window—maybe 5 x 5 feet—that allows good natural light, the exposure on the Contax 645 with the 80mm F2 lens will be about at f/2 for 1/60 second. With the Canon EOS-1v 35mm and the 50mm F1.2 lens, a typical exposure in this situation will be at f/1.2 for 1/125 second. The bigger the window, the faster the shutter speed, and of course this depends on the lens choice and the aperture I've set for Aperture Priority.

Once the bridal party goes back into their room to hang out, I look around for the groom and groomsmen. Typically, the groom's side comes in and I go through the same process with them.

I try to do as many portraits as possible before the ceremony so they can enjoy their cocktail hour afterward. Once we've worked through all the key combinations, I go to the ceremony site to photograph detail shots before people come in. A lot of people won't even notice these details once everyone arrives, so I want to make sure I capture them and preserve them for the couple.

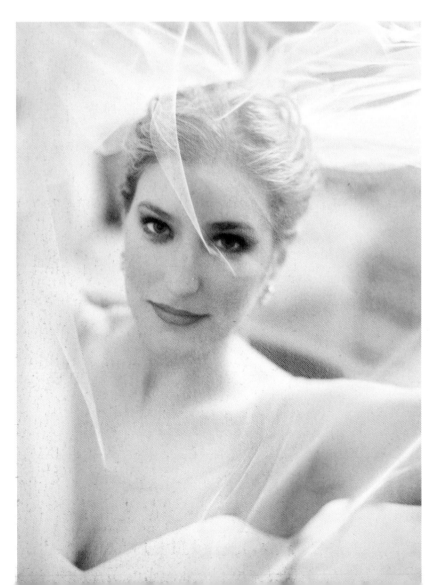

BRIDAL PORTRAIT BASICS

CAMERA: Contax 645 and Canon EOS-1v 35mm SLR with lens

LENS: For Contax, Carl Zeiss 80mm F2; for Canon, Canon 50mm F1.2

FILM: Fujicolor Pro 400H and Fujifilm Neopan 400 rated at ISO 200

EXPOSURE: Aperture Priority set to the max aperture of the lens (f/2 for the Zeiss, f/1.2 for the Canon)

LIGHT: Ambient

LIGHT METER: Sekonic Flash Master L-358 when necessary

PAGE 90 The sun was out during this shoot, but it was a little too harsh, so we went into the shadow of an old barn to get a more even, flat light. As I photographed, a gust of wind picked up her hair for a striking image. Contax 645, 80mm lens, f/2 at 1/500 sec. Fujifilm Pro 400H film rated at 220

LEFT Using soft natural light to illuminate the scene, I asked this bride to lift up her veil and extend it so the creases in the fabric wouldn't be so evident. Then I photographed through the veil. The combination of a shallow depth of field and overexposure made the veil look nearly transparent. Contax 645, 80mm lens, ISO 200, f/2 at 1/125 sec. Fujifilm Neopan 400 film rated at 200

OPPOSITE TOP For this bridal portrait, I positioned the bride with the window to the right and then exposed for the shadow. I had to be careful with my exposure and depth of field so as not to lose too much detail in her veil. I wanted a shallow depth of field with soft focus on the veil but not so soft that the veil blurred to the point of disappearing. Contax 645, 80mm lens, ISO 200, f/2 at 1/30 sec. Fujicolor Pro 400H film rated at 200

OPPOSITE BOTTOM As this bride looked out the window, I exposed for the highlight. something I rarely do unless I want to play up the contrast between a dark room and the light falling on my subject. Contax 645, 80mm lens, ISO 200, f/2 at 1/60 sec. Fujifilm Neopan 400 film rated at 200

When working inside, I make sure I'm by a window to let in some natural light.

Don't Forget the Groom!

ABOVE LEFT Using an old painting in a hacienda in Mexico as a backdrop, I grabbed a quick portrait of the groom as he prepared to meet the bride. Exposing for the shadow on his skin, I got just enough detail in his black tuxedo while still capturing plenty of light on the painting. Contax 645, 80mm lens, ISO 200, f/2 at 1/30 sec. Fujicolor Pro 400H film rated at 200

ABOVE RIGHT Just after this groom had gotten dressed for the wedding, I photographed him in a spot overlooking the beautiful, clear ocean in San Pedro, Belize. It was a bright day, so I positioned him under a porch roof and backlit the scene. Exposing for the shadow on his skin, I shot at 1/500 second to bring in the right amount of light without washing out the exposure. Contax 645, 80mm lens, ISO 200, f/2 at 1/500 sec. Fujicolor Pro 400H film rated at 200

RIGHT I placed this groom in the shadow of an ivy-covered arch, exposed for the shadow, and composed this image using the ivy (in soft focus) on the left to add dimension and draw the viewer to my subject. Contax 645, 80mm lens, ISO 200, f/2 at 1/1000 sec. Fujicolor Pro 400H film rated at 200

OPPOSITE I asked this groom to stand under a weeping willow tree and then backlit him with the sun and exposed for the shadow. Contax 645, 80mm lens, ISO 200, f/2 at 1/1250 sec. Fujicolor Pro 400H film rated at 200

9 The Ceremony

When people start arriving at the ceremony site, there's a great opportunity for some photojournalistic shots. There is so much energy and anticipation. People are hugging, laughing, reminiscing. Maybe the groom hasn't seen Aunt Sally for five years, and they have a touching reunion. There's also a lot of nervous energy as the members of the wedding parties get ready for their big moment. I use my Canon 35mm to capture these scenes, usually working with my 70–200mm lens so I'm not intruding on the moments.

During the ceremony, my main lens is the 70–200mm because it allows me to zoom in close and capture intimate moments while also cropping out unwanted background elements. This lens also allows me to get close to the action without being obtrusive. I use the 16–35mm to bring in more of the scenery and deliver an overall look at the entire scene. I never, ever use a flash during the ceremony. My pockets are loaded with film. For an outdoor ceremony, it's all 400-speed film. In my left, I keep two rolls of black-and-white Fujifilm Neopan 400. In my right, I have two rolls of Fujicolor Pro 400H. For an indoor wedding, I swap out the 400-speed film for 1600- or 3200-speed film, depending on the lighting situation.

As the bride walks toward the groom, I use the Canon EOS-1v with the 70–200mm lens to capture shots of her reaction and her dad's reaction as he escorts her down the aisle. Once they get closer, I switch to my Contax 645 for the more close-up pictures like the father giving the bride away. After that moment, I usually move around to the back of the congregation, hand the Contax to my assistant, and start shooting overall scene images with my other Canon EOS-1v and the 16–35mm lens. Meanwhile, my assistant uses the Contax to take some frames of the entire scene from the back.

As the ceremony proceeds, I focus primarily on the bride and groom with my 70–200mm lens, zooming in to get close-up shots of the ring exchange, their looks at each other, and then maybe some images of their parents' reactions. I am always waiting for the shot of the couple kissing. My objective is to be in front of them as they turn toward the congregation, shooting from the same perspective as the congregation. Usually, I capture this image with the 70–200mm lens and then make several images of them walking down the aisle toward me. I walk down with them, moving backward as they proceed toward me. Once they reach the last row or pew, I ask them to pause and kiss. I get that shot with my 16–35mm for a wide-angle view of them kissing and everyone behind them standing up and clapping. That is a winning shot right there. I did it as an accident once, and I've included it at every wedding I've done since.

The couple usually gets tucked away at this point. In most cases, we've set it up so that we photograph the families and full wedding parties immediately after the ceremony.

CEREMONY BASICS

CAMERA: Contax 645 and Canon EOS-1v 35mm SLR

LENS: For Contax, Carl Zeiss 80mm F2 lens; for Canon, Canon 70–200mm F2.8 and Canon 16–35mm F2.8

FILM: When outside, Fujicolor Pro 400H and Fujifilm Neopan 400 rated at ISO 200; when inside, Kodak T-MAX P3200 rated at ISO 1600

EXPOSURE: Aperture Priority set to the max aperture of the lens

LIGHT: Ambient

PAGE 96 The bride and groom looked to their left as a bridesmaid read a passage from the Bible. I positioned myself behind the celebrant and shot the scene with a wide-angle lens, using the archway to frame my subjects. Canon EOS-1v, 16–35mm lens, ISO 200, f/2.8 at 1/2000 sec. Fujicolor Pro 400H film rated at 200

OPPOSITE Images like this one work well on my website and in marketing materials, because they appear to be part of a story. There is a romantic backlighting as the bride and groom symbolically walks out of the church and into their new life. My clients want that story-telling element; they want something thematic and cohesive, not just a collection of pretty pictures. Canon EOS-1v, 16–35mm lens, ISO 1600, f/2.8 at 1/15 sec. Kodak T-MAX 3200 film rated at 1600

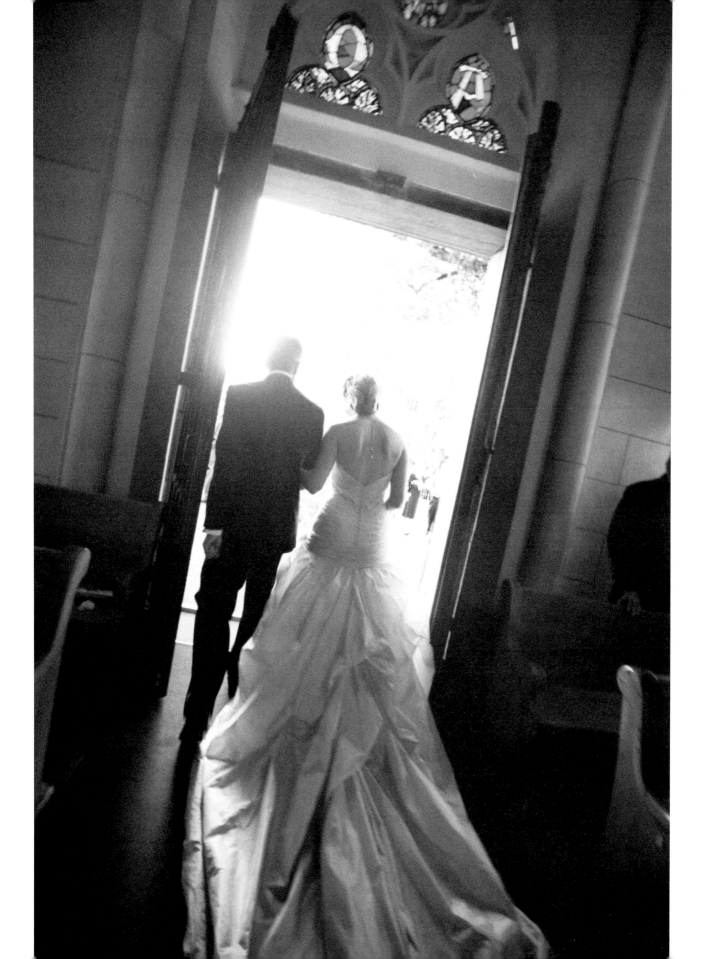

TOP The bride's veil was stuck on the fibers of the church carpet as the couple returned from delivering the floral bouquet to the Virgin Mary. It made a beautiful photographic moment before she untangled herself. I had my Canon SLR ready for just such an impromptu photo op, and I fired off this frame at 1/60 second—just fast enough to stop their motion and just slow enough to bring in the right amount of ambient light from the church windows. Canon EOS-1v, 24–70mm lens, ISO 200, f/2.8 at 1/60 sec. Fujicolor 1600 press film rated at 800

BOTTOM Having just been wed and introduced as husband and wife, this couple was ecstatic. Positioned at the back of the venue, I focused with my 70–200mm zoom lens and captured this image as they grasped hands and prepared to walk down the aisle toward me on their way out of the ceremony site. Canon EOS-1v, 70–200mm lens, ISO 200, f/2.8 at 1/500 sec. Fujicolor Pro 400H film rated at 200

OPPOSITE TOP Shooting from a distance, I captured the bride's cousin playing the violin to the right of the congregation during the halfway point of the ceremony. I composed the image so the large tree blocked the direct sun, creating a backlit effect that added drama to the image. I exposed for the shadow to make sure that I captured enough detail in the figures under the tree. Canon EOS-1v, 16–35mm lens, ISO 200, f/2.8 at 1/2000 sec. Fujifilm Neopan 400 film rated at 200

OPPOSITE BOTTOM MIDDLE The bride and her father locked arms as they got ready to walk down the aisle. With beautiful diffused sunlight shining down through the leaves of the tree, I captured this tender moment on black-and-white film, exposing for the shadow to make sure the shaded areas didn't fall completely into black. Canon EOS-1v, 16–35mm lens, ISO 200, f/2.8 at 1/1250 sec. Fujifilm Neopan 400 film rated at 200

OPPPOSITE BOTTOM RIGHT Using the light of the setting sun, I photographed this bride by exposing for the shadow and bringing in plenty of soft, warm light. The open aperture kept her in good focus while blurring the congregation behind her into a colorful yet smooth backdrop. Contax 645, 80mm lens, ISO 200, f/2 at 1/250 sec. Fujicolor Pro 400H film rated at 200

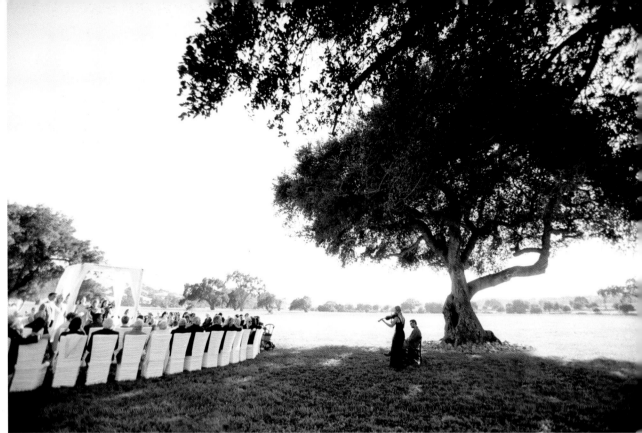

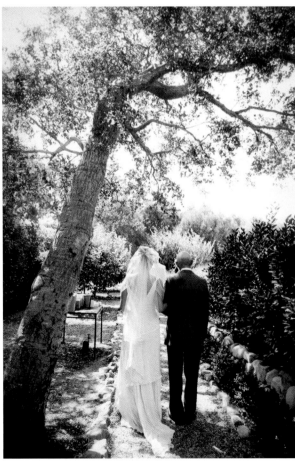
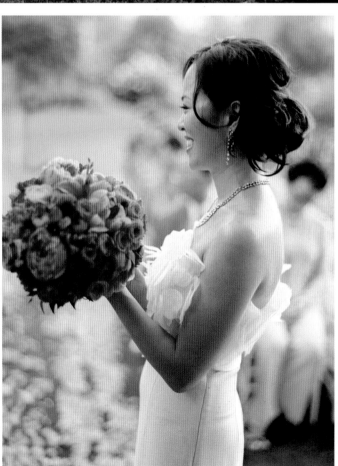

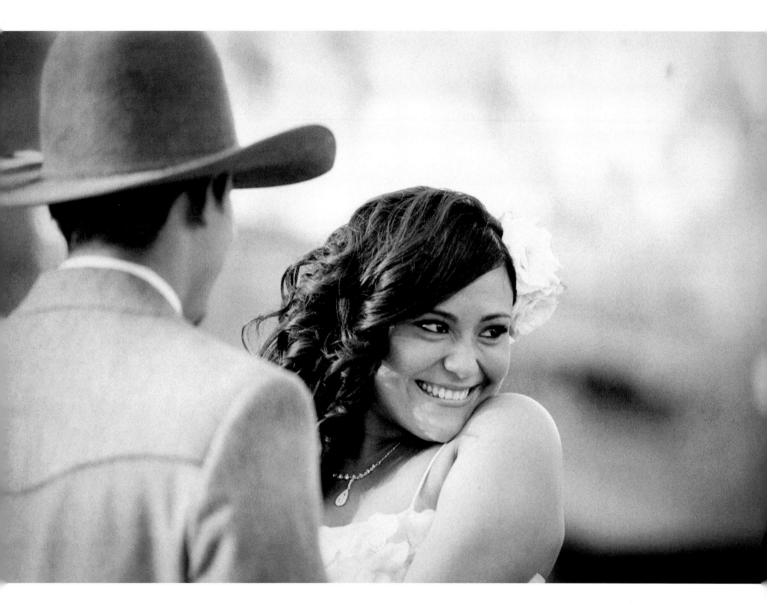

ABOVE Shot with my 70–200mm telephoto lens, this image shows the bride laughing and looking at the pastor as she exchanges vows with her groom. This lens helps me capture these close-up shots of the couples' expressions without being obtrusive. Canon EOS-1v, 70–200mm lens, ISO 200, f/2.8 at 1/500 sec. Fujifilm Neopan 400 film rated at 200

OPPOSITE I captured this image as the bride and groom walked down the aisle with their dog. I was standing at the end of the aisle and shooting with my 70–200mm telephoto. Because I had my zoom lens all the way extended, I shot at 1/4000 to prevent motion blur during the hand-held exposure. Canon EOS-1v, 16–35mm lens, ISO 200, f/2.8 at 1/4000 sec. Fujicolor Pro 400H film rated at 200

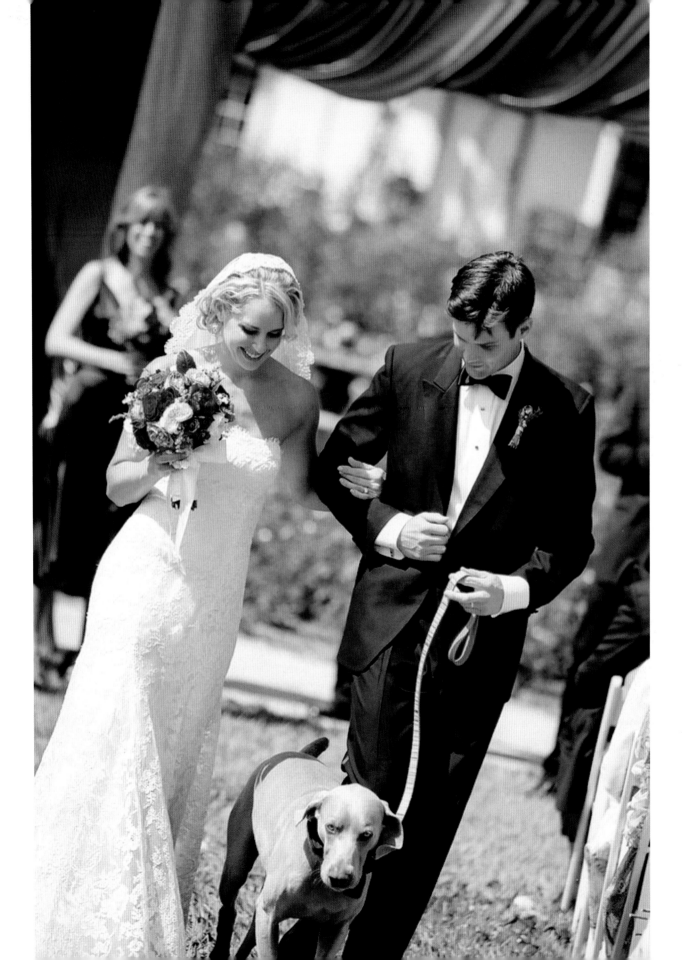

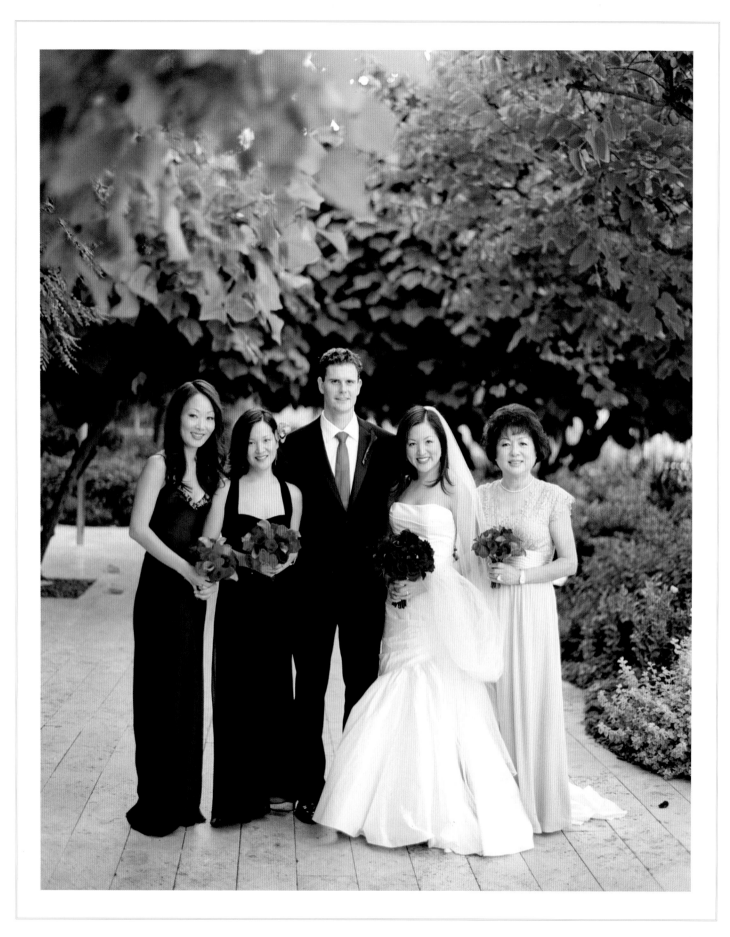

10 Family Portraits

During family portraits, my main camera is my Contax 645, which I load with Fujicolor Pro 400H film. Over my shoulder, I carry my Canon EOS-1v 35mm, which I load with Fujifilm Neopan 400 black-and-white film. While I'm making the main family portraits with the Contax, I keep an eye out for interesting moments—people filtering in and out of the scene, hugging, embracing, laughing, and interacting in fun ways. When one of these moments materializes, I quickly swing around my 35mm and capture a few candid images. The Contax is the portrait camera, while the 35mm is the documentary camera.

I photograph my family portraits with a very shallow depth of field, so I have to make sure that all my subjects are on the same focal plane. I typically work on Aperture Priority at f/2 with my 80mm F2 lens. But if we're outside and the sun is very low, the dim light exaggerates the shallow depth of field. In this situation, it's difficult to get all subjects in focus if they are standing at different depths from my camera. Rather than line everyone up in a flat, boring line, I increase my f-stop to gain more depth of field. In most cases, bumping up from f/2 to f/4 does the trick.

Prior to the ceremony, I scout out a good location for the family portraits. Immediately after the ceremony, I gather the family and the wedding party, and we go right into the portraits. For the family portraits, I typically work with just the immediate family. If my clients want to include their extended family in additional photos, then I usually have my assistant take over, because all those posed family pictures take too much of my time away from focusing on great emotional photographs.

I like to photograph the family first and then let them go. The wedding party sticks around for some additional portraits. I usually photograph the bride and all of her bridesmaids individually and in a group. Then I do the same with the groom and groomsmen before letting everyone go to enjoy the cocktail hour.

The family portraits are strictly scheduled into my time line for the day. People don't want to wait for the photographer. They are at the wedding to enjoy themselves, not pose for portraits. So I get them done quickly. I always remember that my clients' time with their friends and family is precious, and I usually finish my posed portraits in fifteen to thirty minutes.

CAMERA: Contax 645 and Canon EOS 1v 35mm SLR

LENS: For Contax, Carl Zeiss 80mm F2; for Canon, Canon 70–200mm F2.8

FILM: Fujicolor Pro 400H and Fujifilm Neopan 400 rated at ISO 200

EXPOSURE: Aperture Priority set to the max aperture of the lens—except in very low light, when I close the aperture by one f-stop

LIGHT: Ambient

LIGHT METER: Sekonic Flash Master L-358 when necessary

PAGE 104 This location in downtown Los Angeles was probably the only lush spot for several blocks. Luckily, the sun was low enough in the sky to cast a shadow on the family. I exposed for the shadow of the trees and made this portrait. Contax 645, 80mm lens, ISO 200, f/2 at 1/250 sec. Fujicolor Pro 400H film rated at 200

LEFT I loved how this couple used their dog as one of the groomsmen, so I focused this shot on the little pooch while the rest of the group was arranging itself. This is a great example of a fleeting candid moment that I captured with my quicker SLR while setting up a shot with my medium-format camera. Canon EOS-1v, 16–35mm lens, ISO 200, f/2.8 at 1/500 sec. Fujifilm Neopan 400 film rated at 200

OPPOSITE The sunlight had dipped behind the big tree, lighting the fabric backdrop perfectly and providing great light on the subjects. I pulled the bride in front of her bridesmaids to add some depth to the image. Contax 645, 80mm lens, ISO 200, f/2 at 1/500 sec. Fujicolor Pro 400H film rated at 200

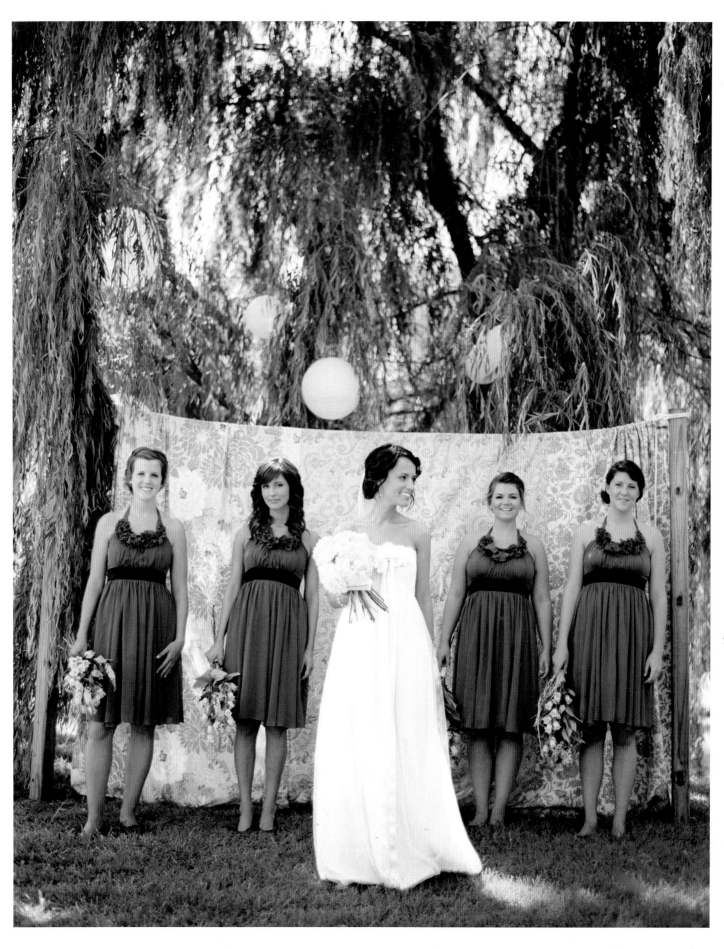

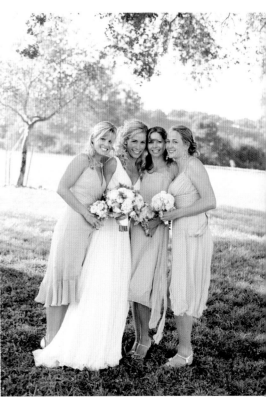

TOP LEFT During this family portrait session, the light was still too harsh to photograph the family photos with skylight as I would have preferred. In situations like this, I just backlight the subjects and expose for the shadow. I never use directional light on family photos because it causes them to squint. Contax 645, 80mm lens, ISO 200, f/2 at 1/500 sec. Fujicolor Pro 400H film rated at 200

BOTTOM The skylight shining on this brother and sister allowed me to shoot freely while they moved around. The soft focus and warm glow on their clothing adds to the sense of carefree childhood joy. Contax 645, 80mm lens, ISO 200, f/2 at 1/30 sec. Fujicolor Pro 400H film rated at 200

ABOVE This was a very bright situation, and the schedule didn't allow the option of waiting for softer, later-day lighting. So I found a tree and placed the women under it for nice, diffused light that would complement my subjects' features. I then photographed at a relatively fast shutter speed to make sure I wouldn't wash out the image. Contax 645, 80mm lens, ISO 200, f/2 at 1/2000 sec. Fujicolor Pro 400H film rated at 200

OPPOSITE TOP Grandma was very happy that her granddaughter had just gotten married. She smiled wide and gave me a great expression. I captured this image with an open aperture and exposed for the shadow on her skin. This is a great example of the general candid imagery that I try to capture in the early parts of the cocktail hour and reception. Contax 645, 80mm lens, ISO 200, f/2 at 1/250 sec. Fujifilm Neopan 400 film rated at 200

OPPOSITE BOTTOM As I was getting ready to do a full-family portrait, I snuck in this shot of the mother of the groom looking at her son proudly. Shooting with my Canon SLR and 16–35mm lens, I cropped out the other family members to focus in on this special look from mother to son. Canon EOS-1v, 16–35mm lens, ISO 200, f/2.8 at 1/1000 sec. Fujifilm Neopan 400 film rated at 200

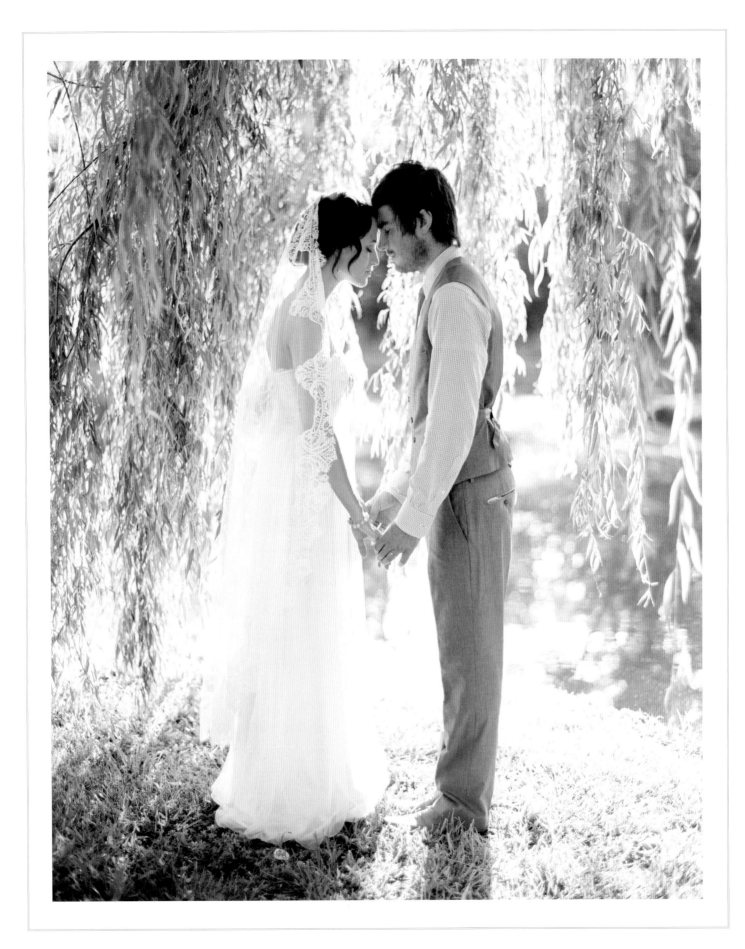

11 Bride and Groom Portraits

Depending on the schedule, the ideal time for bride-and-groom portraits may fall just after the family portraits, during the cocktail hour, during the reception, or somewhere in between. I like to conduct this minisession right at sunset, photographing as the light fades from a warm glow to the soft, omnidirectional "skylight" I describe in Chapter 1.

If this time falls during the reception, I try my best to work in between dinner courses. It can be a balancing act with the food service, but I try to never take my clients away from a warm plate of food!

When we go outside for the portrait session, my assistant usually shoots with a 35mm camera, and I work with the Contax and another 35mm. I use the Contax about 90 percent of the time during these sessions, especially if the sun is setting. I'll photograph a roll, and while it's winding, I'll hand the camera to my assistant to load a new roll while I shoot some frames with the 35mm. The clock is ticking, and I do not want to keep my clients waiting. And I certainly don't want them standing there looking at me and thinking *Now what?*

You have to respect your clients' time. I don't keep them away from their reception for more than fifteen minutes unless they really want some extra shots. In those cases, we might go to thirty or forty-five minutes. I let my clients gauge this, and I always discuss the time line with them ahead of time.

This mini portrait session is when I capture many of my signature images. I do a fair amount of directing during the portraits, but I'm always going for a natural feel. As I say in Chapter 4, Direction, my goal is to put my subjects into good photographic situations and then let them interact as genuinely as possible. I always position them in areas of great light with clean backgrounds, and then I work freely as they enjoy a few semiprivate moments away from all of their guests.

While the sun is still above the horizon, I work primarily with 400-speed film rated at 200. When the sun dips completely below the horizon, I have about ten to twelve minutes of perfect residual "skylight" to shoot my clients from all angles. I work feverishly during this time, photographing as much as possible in this soft light before it falls to complete darkness. For these last few portraits before dark, I'm usually working with 800-speed film rated at 400, or possibly 1600 rated at 800 if the shadows are advancing particularly fast.

BRIDE AND GROOM PORTRAIT BASICS

CAMERA: Contax 645 and Canon EOS-1v 35mm SLR

LENS: For Contax, Carl Zeiss 80mm F2; for Canon, Canon 70–200mm F2.8 and 16–35mm F2.8

FILM: Fujicolor Pro 400H rated at 200, Fujicolor Pro 800Z rated at 400, and Fujicolor Superia 1600 rated at 800

EXPOSURE: Aperture Priority set to the max aperture of the lens

LIGHT: Ambient

LIGHT METER: Sekonic Flash Master L-358 when necessary

PAGE 110 This image demonstrates my backlighting technique at midday. Working during the brightest part of the day, I placed the couple underneath a willow tree, where the long, leafy braches diffused the harsh overhead light and created some nice shade. Shooting with the sun behind the subjects, I exposed for the shadow on their faces. I let the sunlight fall on back of their heads and overexposed a stop so the light would wrap around and give off a soft glow. Canon EOS-1v, 16–35mm lens, ISO 200, f/2.8 at 1/2000 sec. Fujicolor Pro 400H film rated at 200

LEFT The bride and groom stood in front of the blue wall in the shadow of a tall building. I cropped out the busy surroundings. Shooting with an open aperture, I exposed for the shadow on their skin. Canon EOS-1v 16–35mm lens, ISO 200, f/2.8 at 1/125 sec. Fujicolor Pro 400H film rated at 200

OPPOSITE We did this shoot at sunset with a brisk breeze chilling the bride in her strapless dress. I assured her that the images were going to be amazing, even though she was cold. She smiled, and I captured this intimate portrait. Contax 645, 80mm lens, ISO 200, f/2 at 1/250 sec. Fujicolor Pro 400H film rated at 200

ABOVE I caught this brief moment as the bride and groom looked behind me at their best man walking around them. I had my SLR ready for a shot like this, so I focused quickly and captured their amused expressions while diffused sunlight backlit the scene. Canon EOS-1v, 16–35mm lens, ISO 200, f/2.8 at 1/2000 sec. Fujifilm Neopan 400 film rated at 200

RIGHT This image is from my baby sister's wedding. I asked my sister to play with her husband's hat while he played with her bouquet. Using these props, I was able to get them to loosen up and have fun with the session, which elicited these great expressions. Contax 645, 80mm lens, ISO 200, f/2 at 1/125 sec. Fujicolor Pro 400H film rated at 200

OPPOSITE TOP The bride and groom embraced as the sun set on the beach. I backlit the couple with the fading sun and exposed for the shadow on their skin. The sunlight created a warm glow while I maintained plenty of detail in the dark areas of the image. Contax 645, 80mm lens, ISO 200, f/2 at 1/125 sec. Fujicolor Pro 400H film rated at 200

fine art wedding photography

BELOW LEFT With the bride and groom standing between lavender fields, I asked the groom to kiss his bride's cheek. I loved her hair and wanted to get a shot that showed the back of her head while still focusing on the groom's face. The sunlight was diffused by the trees behind them, producing a beautiful effect and warm, even light. I exposed for the shadow. Contax 645, 80mm lens, ISO 200, f/2 at 1/250 sec. Fujicolor Pro 400H film rated at 200

BELOW RIGHT This couple had an amazing sense of style and very creative ideas, including riding this tandem bike into the reception for their grand entrance. These images had great appeal to magazines because of the unique design and fun twists the couple imagined. The photos were posted on countless blogs and run in several magazines. *Martha Stewart Weddings* ran a full feature on this wedding. Contax 645, 80mm lens, ISO 200, f/2 at 1/125 sec. Fujicolor Pro 400H film rated at 200

12 The Cocktail Hour and Reception

During the cocktail hour, my assistant and I mill around and capture candid images of the guests and the wedding party. As opposed to the candids I shoot in the moments leading up to the ceremony—when an anticipatory, slightly nervous energy permeates the scene—cocktail hour candids are all about a relaxed sense of joy. Everyone is feeling good, and there's an easygoing feeling of general happiness as the celebration starts to kick into gear.

After I've grabbed a few good shots of people socializing, I go to the reception site to photograph details. I usually spend about fifteen to twenty minutes on these reception-site detail shots, covering menus, place settings, centerpieces, name cards, candles, flowers, overall room shots, and the cake, if it's already out.

At the reception, I work primarily with my Contax 645 and 80mm F2 lens. My assistant holds a video light to provide warm, consistent light. I use the video light to backlight some detail scenes as well.

For the couple's grand entrance to their reception, I often switch to my Canon EOS-1v 35mm camera and 70–200mm lens, and I attach my Canon Speedlite flash, set to ETTL −1/3. I use the flash here to help freeze motion as the couple moves quickly through the crowd.

I'm always keeping an eye on the outside light and waiting for the right opportunity to capture sunset portraits of the bride and groom. After we've captured those portraits and the couple has settled in for their dinner, my assistant and I take a break. We usually relax for about twenty minutes, get something to eat, drink some water, and recharge for the final stretch of the day.

During the toasts and some of the initial dancing, I hang around the periphery of the scene and capture a few images of people's emotions. I usually work with my Canon EOS-1v and 70–200mm zoom lens so that I can zoom in on people's faces without being too obtrusive.

When the couple goes into their first dance and cake cutting, I switch back to my Contax 645 with the video light. I'll often blur the motion intentionally, depicting a sense of movement that brings the images to life.

During this segment, I like to load my camera with Kodak T-MAX P3200 film or Ilford Delta 3200 film, both of which I rate at 1600. These films give a nice grainy look that adds a timeless, romantic feel to the dancing images. But this isn't an automatic switch. I have to test the lighting situation in advance to make sure the lighting is right. These 3200-speed films get overly grainy in very low or very bright light, so I use them only if the combination of ambient and video light is perfect. With digital capture, you can adjust your ISO settings for the right effect and test your exposures while shooting. Depending on your camera, you might experience a grain issue with low-light exposures at ISO 1600, but you can see your results on the LCD screen instantly and make adjustments. The key is to evaluate the lighting situation at every event—and repeatedly during the event—to ensure that you're creating the right mood while still making viable exposures.

When the party kicks into gear and everyone starts dancing, I light with my video light as much as possible. I try to use my Contax 645 loaded with 3200-speed film (rated at 1600) wherever possible, but I shoot most of the dancing shots with my Canon 35mm, also with 3200-speed film. In general, I use the 35mm with either the 70–200mm or 16–35mm lens for the faster-moving, candid images, and I often freeze motion with the Canon Speedlite flash. The Contax works better for the first dance, which is usually to a slower tune, as well as the cake cutting and other events for which the motion isn't quite so quick.

fine art wedding photography

CAMERA: Contax 645 and Canon EOS-1v 35mm SLR

LENS: For Contax, Carl Zeiss 80mm F2; for Canon, Canon 70–200mm F2.8 and 16–35mm F2.8

FILM: Fujicolor Pro 400H and Fujifilm Neopan 400 rated at ISO 200, Fujicolor Pro 800Z rated at 400, Fujicolor Superia 1600 rated at 800, Ilford Delta 3200 rated at 150 1600, and Kodak T-MAX P3200 rated at ISO 1600

EXPOSURE: Aperture Priority set to the max aperture of the lens

LIGHT: Video light and some flash

LIGHT METER: Sekonic Flash Master L-358 when necessary

PAGE 116 The bride had set up all the floral arrangements and the details on the table with her mother's help. When she saw the images later, she was so thankful that I had taken the time to document all these little touches. Working with my typically shallow depth of field, I focused on the middle floral arrangement and let the rest of this colorful scene go soft. Contax 645, 80mm lens, ISO 200, f/2 at 1/500 sec. Fujicolor Pro 400H film rated at 200

OPPOSITE For this image, I took advantage of twilight lighting coming in from the outside. I shot some images of the cake when the light was higher, but I liked the moodiness of this image. The soft twilight provided the right amount of light as well as some color in the window. By exposing for the shadow, I made sure to capture plenty of detail in the darker areas. Contax 645, 80mm lens, ISO 400, f/2 at 1/125 sec. Fujicolor Pro 800 NPZ film rated at 200

Be Detail Oriented

Detail shots are essential for creating a sense of place and for documenting the overall design of the event. Couples spend a tremendous amount of time, energy, and money crafting a design that runs through everything, from the invitations to the place settings. They always appreciate plenty of images of these design details.

Detail images are critical for good album design. They add visual interest to the album (so it's not exclusively people shots), and they provide a more complete representation of the event. In addition, the colors and design features displayed in detail shots help tie together the pages of an album with a consistent theme.

The cocktail hour and reception is the ideal time to capture detail images. Try to beat the crowd to the venue so that you can get a few minutes of undisturbed shooting. If you need to, grab a few key items and create your own still life. Just arrange the items in ideal light, make a few quality images, and then return everything. Your clients will appreciate the extra effort to recreate their creative vision.

With my standard packages, I don't stay for more than an hour of dancing because it gets repetitive. I explain this to the couple ahead of time and suggest that they orient my time to the earlier parts of the day when I can capture more daytime material during the warm light that works better in my imagery. If they have a grand exit that is special, they might want to extend my time until the end of the reception., but that's a substantial extra expense and may make sense for the couple only if there is something spectacular at the end of the reception.

LEFT The bride and groom held hands as they exited their vineyard reception. I used my flash at ETTL –1/3 with my camera on Aperture Priority. I wanted some slight blur to depict their movement, but I also wanted to freeze them enough to capture their expressions. So I shot with an open aperture at 1/60 and fired my Canon Speedlite 580EX. Canon EOS-1v, 16–35mm lens, ISO 1600, f/2.8 at 1/60 sec. Kodak T-MAX P3200 film rated at 1600

OPPOSITE I captured this image in the car as we were driving behind the couple on the way to the reception. I knew the car was going to turn, so I told my assistant to hold the steering wheel as I snapped a few shots. I shot with a relatively slow shutter speed to allow the street and car lights to flare and glow a bit. Contax 645, 80mm lens, ISO 1600, f/2 at 1/30 sec. Kodak T-MAX P3200 film, rated at 1600

Lesson Learned

A few years ago, I had a wedding coming up, and I repeatedly asked the wedding planner for a time line. She kept promising to send it, but when the wedding day arrived, I still had no schedule.

The reception is a time when events tend to pile up in rapid sequence. If you're not on top of the schedule and aware of what's happening next, you could miss something critical. At this particular wedding, we were flying by the seat of our pants because we didn't have a schedule. When it seemed like there was a bit of a lull, we took a much-needed little break. All of the sudden, I looked over and saw the first dance was happening. No one had told me. No one had made an announcement. The couple just got up and started dancing! I was completely unprepared. I didn't have the right camera or the right lenses. I couldn't find my assistant. My work takes a little bit of preparation—I don't just shoot from the hip—so I was panicking about the prospect of missing the whole dance before I got everything set up to shoot properly. I could see the couple in the distance dancing, and I could also see some of the guests looking at me and wondering what I was doing. I was clearly freaking out a little, and people were noticing.

The first thing I did was take a deep breath and tell myself to calm down. Then I found my camera bag, grabbed the appropriate camera and lens, and hustled to the dance floor. Thankfully, my assistant had been heads-up enough to recognize what was happening, and she met me en route to the dance floor. We got the video light going, and I fired off two shots before the song ended.

Thankfully, the two frames I captured turned out great, and the couple never knew about the near miss. Still, it's not a situation I want to repeat. Now I always make sure that I'm overly prepared. I start asking planners or clients for a time line months in advance, and I don't relent until I get that schedule. People sometimes tell me, "Oh, don't worry about it. We'll make announcements before all the big stuff." Not good enough. I make absolutely certain that I have a time frame so I can prepare myself in advance.

fine art wedding photography

Capturing Emotion

Creating images that reflect the excitement, anticipation, joy, romance, and, of course, love at any wedding is one of the keys to great photography. The fine art approach should depict and evoke genuine emotions.

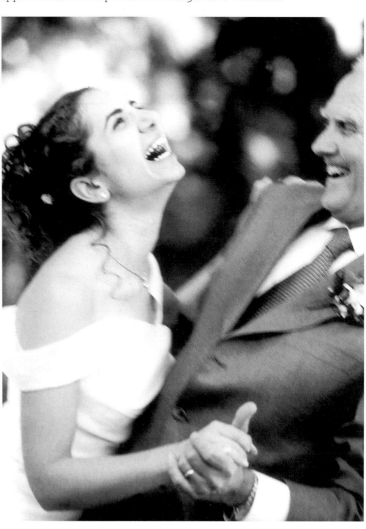

ABOVE LEFT I shot this photograph with my telephoto lens during the father-daughter dance. Moments like these are gone in a split second, and you have to be ready and know when that next great moment is coming. Anticipation is key. Canon EOS-1v, 70–200mm lens, ISO 200, f/2.8 at 1/30 sec. Fujifilm Neopan 400 film rated at 200

ABOVE The bride smiled from ear to ear while dancing with the father of the groom. In this situation, I had my Canon SLR and 70-200mm lens focused on the subjects, waiting for the moment to develop. Canon EOS-1v, 70–200mm lens, ISO 1600, f/2.8 at 1/15 sec. Kodak T-MAX P3200 film rated at 1600

OPPOSITE The sun was about to set as the bride and groom danced in a barn draped in white curtains. I decided to use Fujicolor 800 NPZ film so I wouldn't get too much blur. The film choice helped the skin tones stay very true to their original colors. With digital capture, you can work with your ISO, f-stop, and shutter-speed settings to accomplish the right balance of warm light and true color. Contax 645, 80mm lens, ISO 400, f/2 at 1/125 sec. Fujicolor 800 NPZ film rated at 400

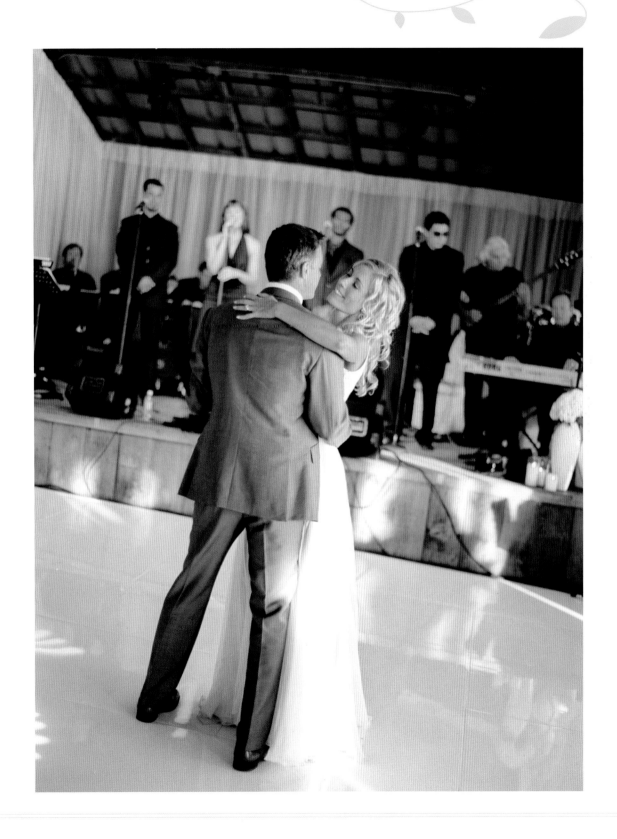

123

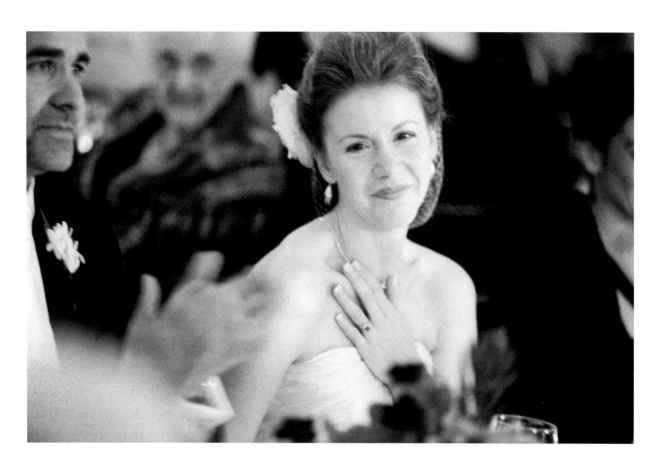

ABOVE A groomsman was making a toast, and I was able to get the bride's reaction. I love the little bit of blur in this image, which makes it seem more alive. I achieved that sense of motion by shooting at 1/15 second. Canon EOS-1v, 70–200mm lens, ISO 1600, f/2.8 at 1/15 sec. Kodak T-MAX P3200 film rated at 1600

OPPOSITE TOP Shooting with my 70–200mm telephoto, I cropped this image closely in camera to focus on the grandparents of the groom exchanging a few words as they waited for the bride to walk down the aisle. This was a crowded scene with lots of people around the subjects, but I removed the distractions by zeroing in tightly and removing the other people from the frame. Canon EOS-1v, 70–200mm lens, ISO 200, f/2.8 at 1/500 sec. Fujifilm Neopan 400 film rated at 200

OPPOSITE BOTTOM In this image, I caught the brief moment when the groom embraced his father, whom he hadn't seen for about a year before the wedding. I was able to capture this split-second moment because I did my research on the families ahead of time and anticipated this emotional greeting. Canon EOS-1v, 70–200mm lens, ISO 200, f/2.8 at 1/30 sec. Fujifilm Neopan 400 film rated at 200

After the Big Day

Great photography has to be followed up with great customer service and top-notch products. If you want to cultivate a high-end clientele, then every element of your process needs to be consistent, from your initial contact with a prospect to the delivery of your final materials. There can be no weak links.

Two weeks after their wedding, my clients receive photographs. For a seven-hour event, they get a Cypress display box full of 600 4 x 6 proof prints, all printed on archival Fuji paper with a custom border. I offer five borders: plain white, sloppy, rounded edge, and key line. Printing with a border ensures that I'm getting the full image, not the slight crop you receive with a bleed print.

I give clients actual proof prints because I want them to have something tangible in their hands, something with immediate artistic value. I customize the Cypress box to the couple's wedding colors for an extra touch of class. Also, I make sure to file the images in chronological order and include contact sheets. You can't just hand someone a jumbled box of pictures and expect them to appreciate the full scope of your work.

The album design process begins two to three weeks after the couple receives their prints. If they haven't contacted me about their album by their one-year anniversary, I contact them and nudge the process along. Since many couples have a hard time editing down their six hundred proofs into an album of reasonable size, I help them by selecting my favorite seventy-five images for their album.

I have high-res scans made of the seventy-five final images and begin the process of retouching every single file. My process is simple: In the Levels feature in Adobe Photoshop, I up the levels to give the images a brighter tone and then drop the shadows a little to make the dark spaces darker. This process saturates the image a bit more—nothing crazy, but it delivers a nice pop. I never sharpen images because I am looking for a softer look to the images (which is why I shoot film in the first place).

Then I begin laying out the album page by page. Album design is very important in the overall presentation of my imagery. As I photograph, I think about how the images will fit into the final album design. Then, when I lay out the images, I employ plenty of white space for a clean, open design that matches the photography. I try to incorporate all the different elements that my clients put into their wedding so the album tells the full story of the day.

A typical book has eighteen to twenty pages, usually organized chronologically. When I have a draft ready, I e-mail the clients my page layouts and have them sign off, move around photos, or add in other requests. We often go through two to three revisions before we're ready to print the final book. I personally check the album before sending it to the bride and groom.

At the conclusion of this process, I give my clients the negatives from their event. I charge for these in the original package, so I've already been compensated accordingly. If the clients want additional prints in larger sizes (11 x 14 or bigger), I hang on to those negatives until the prints are back from the lab. If they want smaller prints, those can be done from the DVD of high-res scans. Speaking of the DVD of digital images, I do offer that for sale at an additional price.

ABOVE As the sun was setting, I stole a couple minutes to capture this image of the "wedding" sign. It made a great scene-setting photo for the wedding album. Contax 645, 80mm lens, ISO 200, f/2 at 1/1000 sec. Fujicolor Pro 400H film rated at 200

OPPOSITE Shooting with skylight in the shadow of the Grace Cathedral in San Francisco, I saw the elegance of how this bride held her gown and bouquet and captured this image. I framed the couple within the archway at the entrance to the church, producing a sense of drama and scale. Contax 645, 80mm lens, ISO 200 f/2 at 1/60 sec. Fujicolor Pro 400H film rated at 200

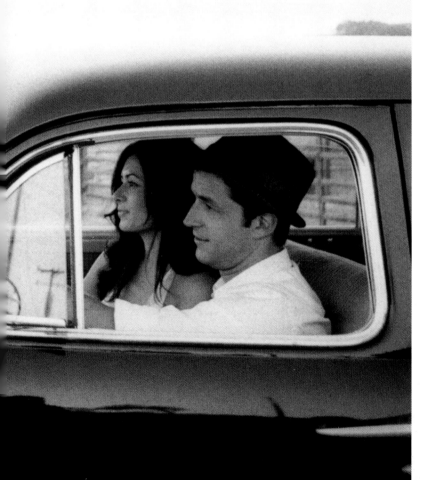

part 3
the business of fine art wedding photography

Establishing a photography business with a fine art angle means courting a specific, high-end clientele that both appreciates photography and is willing to pay a premium for it. Backed by strong marketing and superlative service, the fine art approach could be your stairway to the next level of success.

This couple wanted a portrait of themselves driving the vintage car that inspired their wedding décor. Shooting with Fuji black-and-white film, I oriented my subjects in the bottom right corner of the frame with the hood of the car and the primary open space in the frame in front of them to imply forward movement. Canon EOS-1v, 16–35mm lens, ISO 200, f/2.8 at 1/1000 sec. Fujifilm Neopan 400 film rated at 200

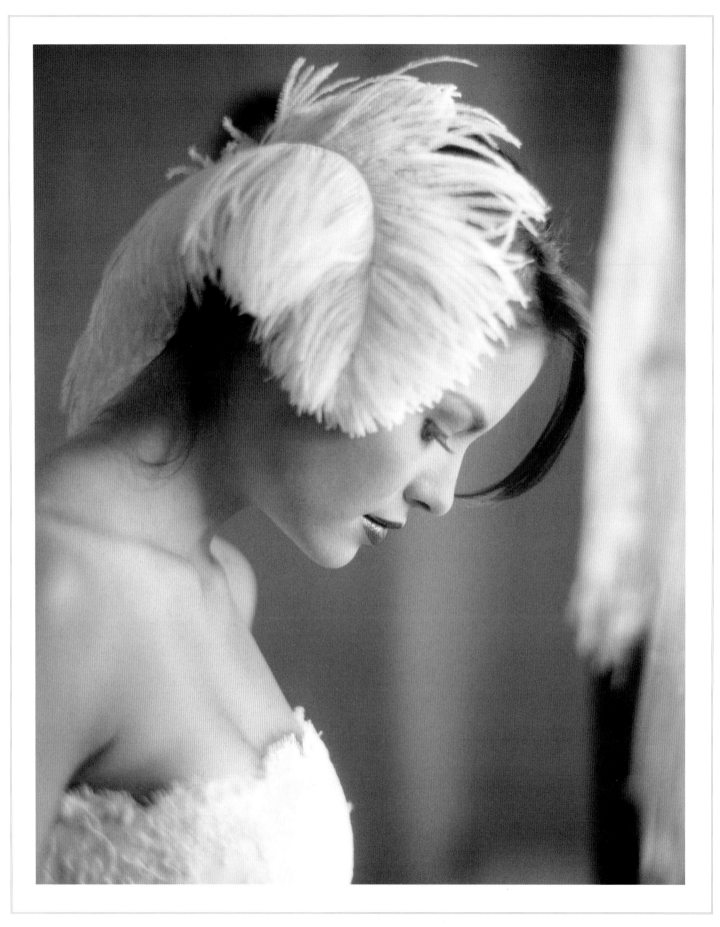

13 Marketing the Fine Art Approach

As my business has evolved, I've become increasingly focused on a core clientele, and I've discovered how to best appeal to that target market. As opposed to early in my career—when I simply created art and figured the business would follow—I now put a real emphasis on building a consistent image, getting my work seen in the right venues, and establishing long-lasting relationships that lead to the right kinds of referrals. Ultimately, I want to create a strong brand that will trickle down through the referral channels until my ideal clients call me. I want those personal and professional referrals from people who "get me" more than any other business leads, because those types of clients help me grow my business and improve my art.

Consistency is critical. Your materials, the way you present yourself, how you show your images—it all needs to be consistent with your brand and your overall business image. When you walk into my office, it's like you're walking into my website. My website and blog are virtual representations of my physical business materials. That consistency in presentation is essential.

Consistency

My website and blog are virtual representations of my physical business materials. That consistency in presentation is essential.

Always show your best work. Show the work that demonstrates what you want to do and includes the types of clients you want for your business. Don't display work that's mediocre. If you show images that aren't your best, or that aren't close to your heart, it attracts clients you don't necessarily want.

Your presentation doesn't go unnoticed. That's why I send the hand-signed packages to prospective clients. That's why I send proof prints in high-quality display boxes. That's why I use the best quality albums I can find. Make sure your products and presentation items are a solid representation of who you are as an artist and how you do business as a professional. Make your materials nice enough that clients are proud to show friends and family. When they are proud of their wedding-image presentations, they will show them to everyone. That leads to referrals and new inquiries about your services. You never know when one of your clients' friends might be a new potential client.

Website

Ideally, you point your online marketing back to a professional, well-branded website.

Despite the rise of blogs as an alternative to a full-featured website, my website remains an important part of my marketing package. The website is the professional

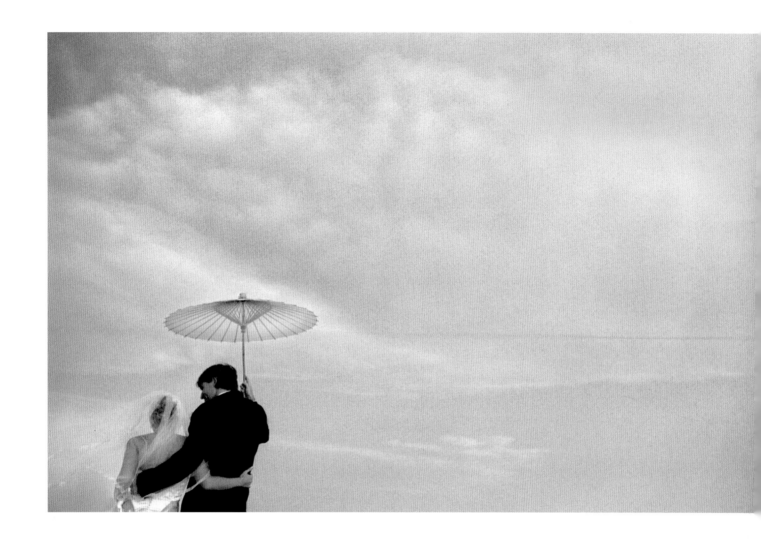

gallery of my imagery, whereas the blog is a more personal expression of my work and personality. To appeal to a high-end clientele, I believe that it's important to have a high-end online presence. A website is like your virtual storefront. It needs to represent you at the most professional level so that potential clients recognize that you're the complete package; you haven't cut corners and you won't accept an inferior product. If your website works perfectly and looks impeccable, the implication is that you do, too.

ABOVE Consistency is essential when appealing to a selective audience. In this image, the lower corner placement of the subjects, the slight overexposure, the use of an interesting prop (the umbrella) that's tied to the wedding décor—are all consistent elements in my work that clients recognize and appreciate. Canon EOS-1v, 24–70mm, ISO 200, f/2.8 at 1/2000 sec. Fujicolor Pro 400H film rated at 200

PAGE 130 With window light shining directly in front of her, this bride looked down as I composed this portrait during her getting-ready stage. The soft window light provided the perfect illumination for an open-aperture capture in which her face and accessories are in sharp focus and the distracting background elements go soft for a clean overall composition. The bit of white fabric hanging on the right side of the background provides some balance with the white dress and hairpiece. Contax 645, 80mm lens, ISO 200, f/2 at 1/125 sec. Fujicolor Pro 400H film rated at 200

Building a business by referral helps you establish long-term, trusting relationships with vendors. It also costs a lot less than traditional advertising. At the beginning of my career, I put out a few expensive magazine ads. From those ads, I got a couple of calls from brides, but I didn't book a high percentage. My booking rate from referrals is exponentially higher, and it costs a fraction of what I used to spend on magazine advertising. Now, I'm not

Business by Referral

opposed to paid advertising. It has its place, especially as a way of letting vendors know you're out there. Even if you don't get direct bookings, your advertising may put you on the radar screen of key vendors and planners, which may pay off down the road. But once you are more established, you can back off the ads and work more through the network you've already established.

These days, about 45 to 50 percent of my business comes from word-of-mouth client referrals. Referred prospects are much easier to sell than are those who come to you out of the blue. Many of these prospects have actually seen me work at a wedding, or the referrer has explained how I operate. So they get it. They understand me. They're usually calling to see if I'm available and what my rates are. I book about 90 to 95 percent of such referrals.

Wedding Planners

Wedding planners work as a team with wedding photographers, so they want to find people they can trust. If you want to work with wedding planners, you have to respect what they do, and you have to work in a way that makes their job easier. Think of it as a team of artists working to create the best product for the client. To encourage referrals from wedding planners, I always make sure to send them great overall pictures of the events we've worked on together. They're going to be most interested in the overall-scene shots, the images that show the full design of the event.

OPPOSITE If you create images that make your clients look their best—a stylized, idealized view of their big day—they are much more likely to refer you to your friends and family. In this image, I shot with a wide-angle lens and asked bride and groom to look away from each other. I then composed the shot so that I cropped the upper half of their heads to create a unique composition. Canon EOS-1v, 16–35mm lens, ISO 200, f/2.8 at 1/500 sec. Fujicolor Pro 400H film rated at 200

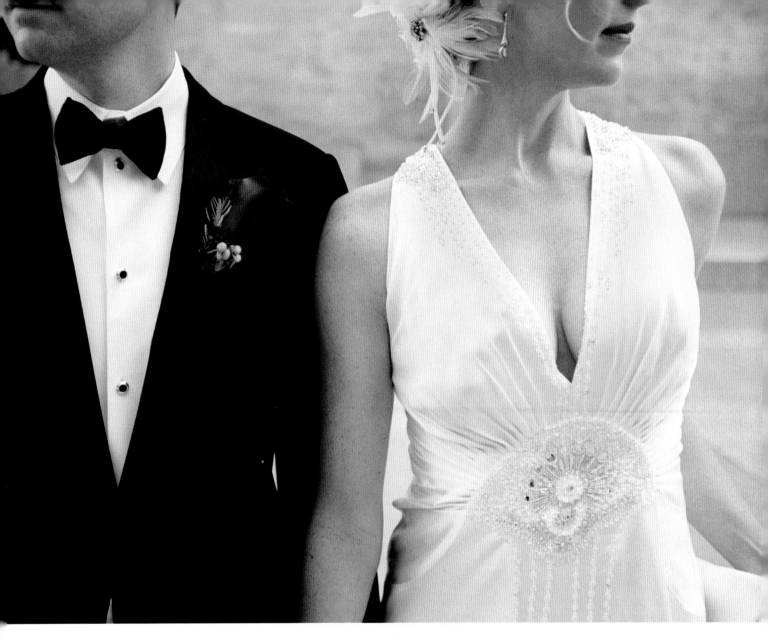

Other Vendors

I also send images to other vendors to make sure they refer me. These vendors include florists, cake bakers, caterers, venue managers, and everyone else involved in pulling off a successful event. After each wedding, when I get back the images, I pull out all the shots of the flowers, the cake, the food and place settings, and the venue. Then I send those images to the appropriate vendors with a personal note.

Here's a tip: Connect with vendors personally and ask them how they want the images. Don't assume they know Photoshop and understand how to reproduce your work. Ask. Are you going to print the photographs? Are you going to post them to your website? Are you planning to put them on a blog?

In a magazine ad? Then give them the best-quality image they need for the specific application. I also make professional prints for them, so I can control the quality of the images in follow-on applications.

Encourage planners and vendors to post your images on their websites and blogs—with credit. A year or two after I started distributing images to key vendors, my work wound up on the websites for ten of the fifteen wedding planners in Santa Barbara. Brides planning a wedding in the area would get on these websites and see my images. Planner and vendor blogs were also helpful.

As a photographer, it's vital to get eyes on your work in a variety of different media—magazines, books, websites, blogs. It's vital to building your name and your reputation. My strategy for publication has varied over the years, veering from a strict print regimen to more online media. No matter what path to publication you choose, just make sure that you are targeting the right outlets that speak to the right types of clients for your business.

Getting Published

Magazines

Having your images published in magazines is vitally important. In many ways, bridal magazines are the stylistic trendsetters of the industry. In recent years, magazines have focused on lifestyle wedding imagery that depicts the total design of an event. To get published, you need to make sure you're shooting the images that magazines are looking for. That means detail shots, scenics of the entire setup, product-oriented images, and anything else that will help tell the full story of the event. Your first priority always should be your art and your clients, but it doesn't hurt to spend a little extra time capturing the types of images that help you get published.

Early in my career, I pulled out my ten favorite bridal magazines, researched their content and imagery, and then called the editors. Photographers are often intimidated by this sort of outreach. Don't be. Magazine editors are extremely busy people, but their job includes identifying new talent. If you can provide the kind of imagery they need, they will usually be open to speaking with you. The key is to do your research ahead of time. If you want a warm reception from a magazine editor, you need to demonstrate that you know the magazine and that you can provide content that fits the publication. Think like a solution provider: *How can I make this editor's job easier? How can I help make this a better magazine?*

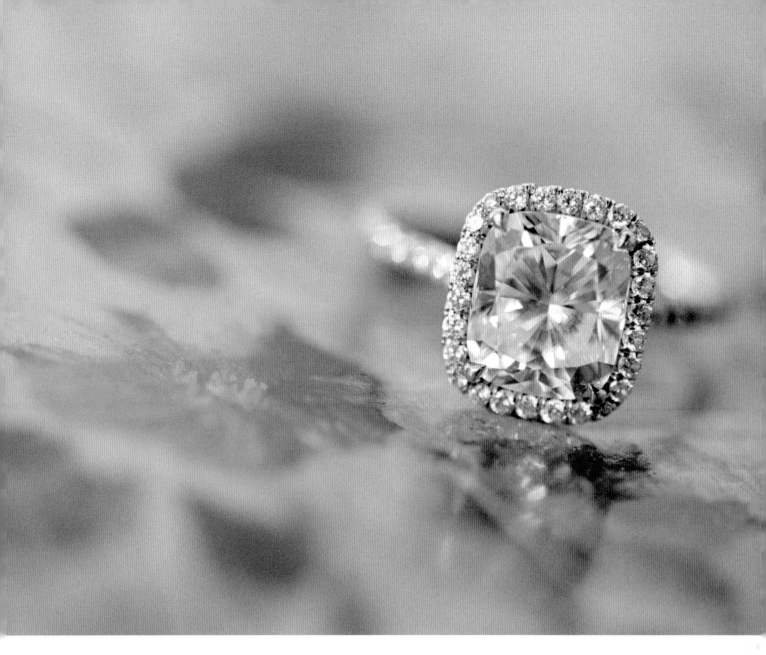

With a little bit of research, you should be able to dig up the key editors' contact information. E-mail addresses are often posted on magazine mastheads or sometimes with the byline of an article. Websites are also useful places to find contact info, including the magazine's main telephone number.

If you don't know the appropriate contact for your query, figure that out first. You don't want to send a query about your amazing wedding images to a part-time copy editor who works two days a week. It also might not be appropriate to contact the editor in chief. Many publications have features editors or photo editors who handle new art submissions. Gathering this information may be as simple as a phone call to the main editorial phone number or an e-mail to a general department address. The question to ask is, "Whom should I contact about submitting images for consideration in your magazine?"

This image of the bride's engagement ring really resonated with wedding bloggers. It ran on StyleMePretty.com, OnceWed.com, and several others. Canon EOS-1v, 100mm lens, ISO 200, f/2.8 at 1/60 sec. Fujicolor Pro 400H film rated at 200

Once you've found the right contact, be polite and persistent but not a pest. If someone doesn't call you back immediately, don't assume that all is lost. Set up a reminder for yourself to follow up in a few weeks. It's best not to remind the editor that she hasn't returned your call or e-mail—this comes off as presumptuous. Instead, just say that you're following up on your call/e-mail and wondered if she would be interested in discussing an image submission.

By following these guidelines, I achieved great success with my initial ten phone calls to editors. At the end of the process, I had five editors who were interested in seeing my images.

From that point, things started happening quickly. When those first few magazines came out with my photographs, the buzz was immediate. Some of the top wedding planners in California saw my work and contacted me for more information. I spent the next month just connecting with planners and vendors who got my work and appreciated it.

The planners helped my business reach the next tier. By booking me on higher-end jobs than I'd previously handled, the planners connected me with a whole new clientele. These more upscale clients were throwing bigger weddings with more intricate designs and more vendors participating in the events. Once I shot a few of these weddings, I submitted more images to the magazines, earning more buzz from that market. The magazine articles showed that I could cover an elaborate event capably, so more of the high-end clients and planners started calling. As I shot more of the upscale weddings, I garnered more attention from bigger bridal magazines that cover those higher-level weddings. And the process continued on an upward trajectory from there.

Blogs

Blogs have changed the wedding photography industry. Many wedding blogs work almost like online magazines. They have feature stories covering real weddings. They include information on vendors and venues. They are fast becoming one of the most vital resources for brides and service providers alike.

Much like print magazines, photographers can shine on blogs because they are a visual medium. Brides do a lot of their initial research online these days, so the more your name appears on the key sites, the better. As prospective clients scan the Internet researching venues and caterers and florists and everything else, you want them repeatedly stumbling across your images. Sooner or later, they'll be prompted to call you.

It's crucial to get credit for images that are used in blogs. Ideally, you can get photo credit with a direct link to your website. That way brides can click on the link and go straight to your site rather than having to look you up.

To make initial contact with some key blogs, I did some research and then contacted the bloggers directly, asking if they could use some of my images to illustrate their posts. All were more than happy to take me up on my offer of free imagery in exchange for a photo credit and a link to my site. Pretty soon I noticed the traffic to my website multiplying. After landing images on several blogs, I saw the hits on my website jump from 30,000 a month to 120,000.

Don't just blindly send photos to anyone who'll take them. Different blogs appeal to different audiences. Just like magazines, some have a high-end readership while others cater to more of a bargain shopper. Make sure that your work gets in front of your target audience. Otherwise, you may find yourself with an onslaught of potential clients who can't afford your services or don't share your artistic sensibilities. Also, make sure you're submitting the right kinds of images to the right kinds of blogs. If you just randomly send pictures, you might end up annoying bloggers who don't consider your work appropriate for their audience.

Multiple Points of Contact

I also maintain my own blog, which is all about the images, as well as Twitter and Facebook accounts. I try to work a little on all these different elements with the understanding that today's marketing is a constantly evolving animal. Things change all the time, and you have to be on top of the changes to stay ahead of the game. Blogging and social media are big today, but they could be obsolete tomorrow. You have to keep your finger on the pulse of the industry to stay current.

They key, I've found, is to have multiple points of contact. Blogging alone won't do it. Magazine publishing alone won't do it. Twitter or Facebook alone won't do it. But if you're out there on all of these media, and your name keeps popping up from different sources and in different circles, then your target audience starts to hear a growing buzz with your name humming through it. That's what you want. It's a subtle sales method. At no point are you

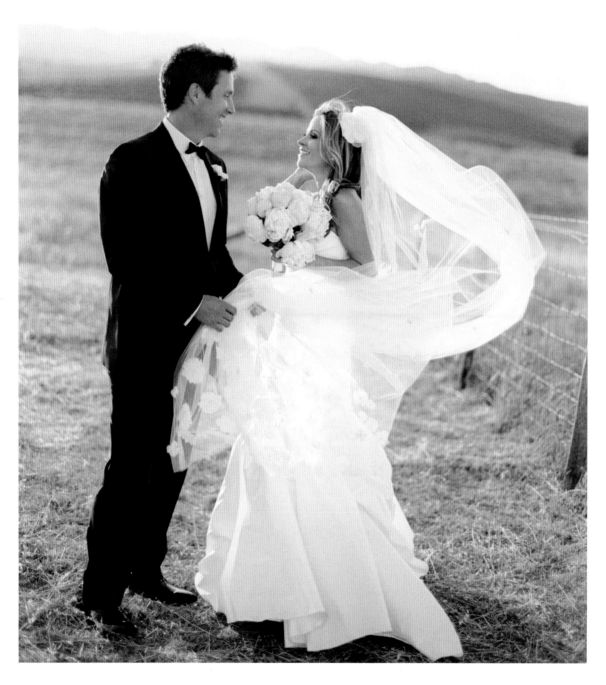

beating your prospects over the head with your message. Instead, they're hearing your name from word-of-mouth referrals, seeing it on blogs, reading it in magazines, catching your Tweets, and seeing your Facebook updates. Eventually, they might want to check you out, and your business grows from there.

The lighting was stunning at this Napa, California, wedding. Images from this event were published in *Cosmopolitan Bride Australia* magazine and in several blogs. The positive publicity led to several new bookings, and I didn't have to spend a cent on promotion! Contax 645, 80mm lens, ISO 200, f/2 at 1/250 sec. Fujicolor Pro 400H film rated at 200

Detail Shots Are Winners

Detail shots are the perfect images to submit for publication. Magazines want to portray the full story of a wedding, and detail shots help you complete the narrative. Bridal publications especially love showing the products couples use at their weddings. It pleases their advertisers (the makers of these products) and gives their readers more ideas for designing their own events.

FAR LEFT I shot these place cards clipped to a clothesline at sunset, selectively focusing on the foreground and letting the background go soft. Contax 645, 80mm lens, ISO 200, f/2 at 1/250 sec. Fujicolor Pro 400H film rated at 200

LEFT Placing this floral bouquet on a bed, resting against a pillow, I backlit the flowers with window light and exposed for the shadow. Contax 645, 80mm lens, ISO 200, f/2 at 1/60 sec. Fujicolor Pro 400H film rated at 200

RIGHT The light in this scene was perfect, and the light bulbs hanging above provided a nice touch. I exposed for the shadow and kept my aperture wide open so that the people in the background would blur into a backdrop and not distract from the cake as the center of interest. Contax 645, 80mm lens, ISO 200, f/2 at 1/500 sec. Fujicolor Pro 400H film rated at 200

OPPOSITE Placing rugs around an outdoor location like this was a unique touch. With late-afternoon sunlight filtering through the trees from camera left, I exposed for the shadow and focused in my shallow depth of field on the items in the foreground. This scene-setting image has made a great detail shot for blogs and magazines. Contax 645, 80mm lens, ISO 200, f/2 at 1/500 sec. Fujicolor Pro 400H film rated at 200

fine art wedding photography

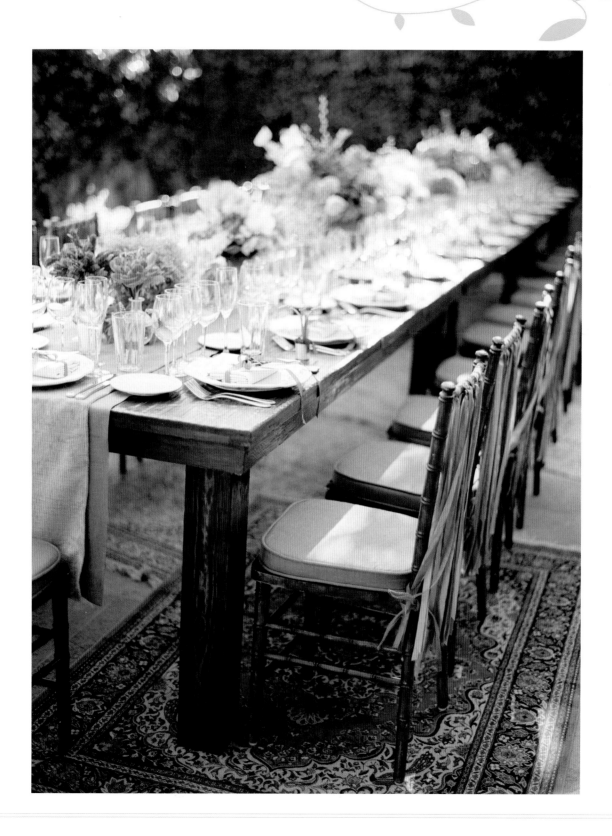

14 Moving to the Next Level

Value is critical at all levels of this business, particularly as you move into the upper price ranges. Discerning clients who prioritize photography understand quality, and they want to make sure their dollars are well spent. As I've expanded my business, raised praises, and moved into more competitive, upper-tier markets, I have continually upgraded my offerings accordingly. But no matter what price range you are in, if you provide value, clients will be happy.

I shot my first wedding for $400. That's right, four hundred bucks. My lab bill was around $350. When you factor in all of my overhead, I probably made $5 off of that event! I knew back then that I had to increase prices, but I didn't have a great perspective on my worth in the marketplace.

In those days, I was fairly casual about my business development. I always provided good service, but I was

PAGE 142 Couples love images that tell a story. The ability to communicate something more than what's clearly visible in the image is what sets apart a fine art wedding photographer from someone who just takes wedding snapshots. It's also something that highly selective clients look for in a photographer. The composition of this image asks a lot of questions. Where is the bride heading? What's at the top of the stairs? Why are the flowers dashed to the ground? It's not only a beautiful portrait; it's the opening scene of an intriguing story. Canon EOS-1v, 16–35mm lens, ISO 200, f/2.8 at 1/500 sec. Fujicolor Pro 400H film rated at 200

Raising Prices

a bit more cavalier about the customer experience. Once I started connecting with wedding planners in my area, I asked for feedback on my business. I wanted to know how to grow the business and appeal to a higher-end client. Right off the bat, several planners suggested that I raise my rates. I was worth more than I was charging, they said, and upscale clients wouldn't take me seriously at my price point. They also helped me recognize the relationship between a total customer experience and a higher price point.

As the business grew and I developed as a professional, I got increasingly hands-on with clients. Within my first year, I bumped up my prices to $1,500 a wedding. Then, over the course of the next several years, I enacted several rate increases, roughly doubling my rates each time as I progressively upgraded my business to go after higher tiers of the marketplace.

With each new tier, with each higher level of clientele, I paid more attention to the overall customer experience. People really want to be taken care of. If you want to compete in upscale markets, taking care of your clients is absolutely essential.

Working with the right kinds of clients is critical to the growth of a photography business. I'm not talking about rich clients willing to pay for large packages; I'm talking about creative, fun people who collaborate in the image-creation process and help make better photographs. In this business, your résumé is your portfolio. With that in mind, if I have an opportunity to work with creative, enthusiastic people, I jump at the chance. This year I shot weddings for ten other wedding photographers. I've also worked with art directors, makeup artists, painters, sculptures, and a variety of other people who know and appreciate art.

Images like this one of a cigar-smoking groomsman have great appeal to magazines, because they help set the mood for a wedding story. And the more stories there are with my work, the more recognition my studio receives. Recognition leads to more upscale clients, which leads to an increase in rates and an upgrade in overall offerings. Canon EOS-1v, 50mm lens, ISO 1600, f/1.2 at 1/15 sec. Kodak T-MAX P3200 film rated at 1600

Part of my attraction to this population is my niche of artistic film capture. People seek me out because of the fine art approach and my work with film. It's a specialty artistic product, and I market it as such. As a result, I'm not competing with every other wedding photographer out there; I'm in a category with just a handful of other specialists.

The idea of producing a specialty artistic product is essential to moving a photography business to the next level. You don't have to shoot medium-format film to carve out a specialty niche, but you do have to produce something unique, something to which your target market assigns a special value. It could be any number of things, as long as it distinguishes you as a producer of high-value items. This is your opportunity to distinguish yourself in your marketplace.

Each time I made a substantial increase in prices, I upgraded the package I offered. That meant improving the quality of my albums, my proof boxes, my note cards, and all my peripheral products. I also rebranded my business at each new price point so that all of my materials corresponded with my higher-end business image.

It's important to use high-quality products that represent your business well, but they also need to be products that you can afford at your current rates. When I was charging $1,500 a wedding, I used a different kind of album than I use now. As I raised prices, I could justify raising my material costs accordingly. Also, I wasn't afraid to negotiate with my providers for better prices. It's okay to ask for deals. Especially if you're doing a substantial amount of business with a company, you can ask for

price breaks as an incentive to keep your business with them. I've saved thousands of dollars over the years by setting up these kinds of arrangements.

Products and branding are the biggest changes at each new price level. Clients are still getting the same photographer with the same artistic vision, the same artistry, and the same personality. You're just offering a more complete package and higher-quality materials. When I thought of it that way, it helped me get over my nervousness about raising prices.

Still, when you raise your rates, it's scary. To some degree, I let my clients tell me what I was worth. When the demand for my work was overwhelming, I'd raise prices as a way of controlling volume while simultaneously advancing the business. One year, I booked more than fifty weddings, and I had calls for more than triple that number. At the end of the year, I was exhausted. So I raised prices the following year. My inquiries and bookings dropped to the point where I shot closer to thirty-five weddings that year, but I made more per event, and my total income for the year actually increased.

When you think about a price increase, do the math. How long do you work on one event? It's not just about the number of hours shooting at the wedding. How long do you spend on postprocessing and editing? Album design? Client interaction? Travel? When you tally it all up, many wedding jobs take more than a hundred hours to complete. Now, divide your total fee (after paying your assistant and other overhead) by the number of hours. That tells you how much you're *really* earning per hour. Your time is valuable, so make sure you're charging for all of it.

I talk to new photographers all the time who don't take their time into account, and it kills their pricing structures. For very modest prices, these photographers offer way too much of their time on the wedding day and way too long in front of the computer editing and doing image enhancements. Many of these photographers stay at weddings for fourteen or fifteen hours for the same price they could have charged for five hours. When you do that, you get taken advantage of. That happened to me earlier in my career. I'd be at an event all day but really shoot for only five or six hours. Brides would tell me, "Wait here until we're ready." They didn't value my time because I hadn't placed an explicit value on it.

Then I changed my packages to include set hours at different rates. Yes, the products vary in my different packages, but the greatest variable, what you're really paying for, is my time. My packages now come in increments of five hours, seven hours, and ten hours of coverage. As soon as I made that change, brides and grooms recognized that they were paying for my time and made efforts to manage their schedules accordingly. Suddenly, I started to hear things like, "The photographer is here! Let's go!" or "Let's move quickly, because the photographer is leaving."

If you want to upgrade to the next tier, think about what you're giving your clients. By pricing correctly, you can be more selective about the clients you work with. Yes, it can be nerve-racking to raise prices, but if you truly believe in yourself, in your art, the business will come your way.

OPPOSITE This couple wanted to be photographed on the Embarcadero in San Francisco because that location had a lot of personal meaning for them. That sense of happiness came out in the photo. Wedding clients love to look happy, and they love to look good. If you can accomplish those tasks while adding positively to the overall experience of their wedding day, you will find yourself courted by increasingly upscale, higher-paying clients. Contax 645, 80mm lens, ISO 200, f/2 at 1/60 sec. Fujicolor Pro 400H film rated at 200

When it comes down to it, establishing pricing is about establishing the customer experience. You want a high-end price tag? Deliver a high-end experience. Presentation, service, and consistency all become increasingly relevant at a higher price point.

When a client first contacts me, her initial questions are "Are you available?" and "What do you cost?" I don't ever discuss pricing over the phone

Presenting Pricing

I'm not afraid to negotiate prices, and I think this flexibility has actually helped upgrade my business more quickly.

during that initial conversation. Instead, I send a collection of images with general information and a rate sheet. The packages include printed pieces with three or four images on an 8.5 x 11–inch sheet of fine art paper. I put twelve different sheets into the packet with a cover page that has a handwritten message, usually something like, "Thank you for your interest. I am still available. Enclosed is my rate sheet."

I send this package so that my prospective clients have something tangible to look through. I want them to enjoy the images and the presentation. I put everything together in a custom-designed white envelope and drop it in the mail.

These promo pieces work like business cards. Brides keep them, put them in a binder, maybe give pages to other brides or vendors they are talking to. They serve as great marketing pieces, regardless of whether the initial prospect ends up booking me or not.

I like the personal touch of the printed piece with the handwritten note. The package costs around six dollars to put together and three dollars to ship, so for less than ten dollars I have a professional, personal way to present my work and my rates, as well as a great promo piece.

If I don't hear back from the couple immediately, I send a follow-up note a couple of weeks later. I usually don't pursue them after that follow-up. If they like me, they like me. If they don't, then I don't want to bother them.

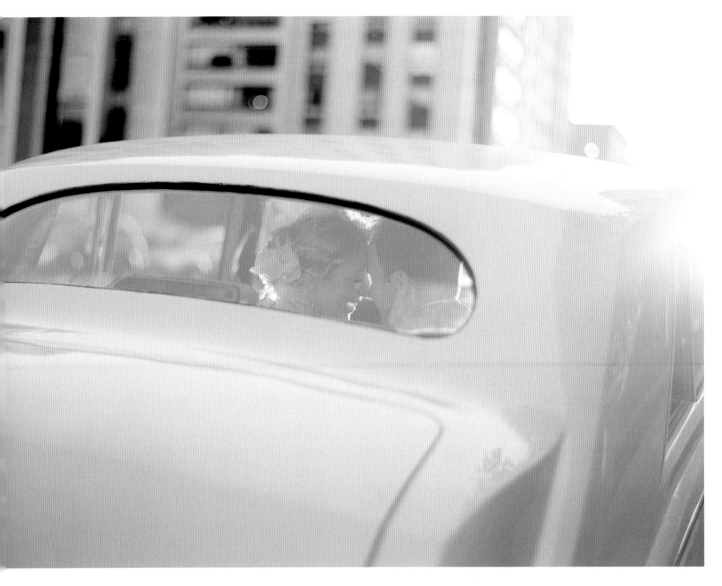

I'm not afraid to negotiate prices, and I think this flexibility has actually helped me upgrade my business more quickly. A lot of photographers draw a line in the sand and say, "These are my prices, and I won't budge." I don't do that. If I meet a couple with whom I really want to work, I'll customize my package based on the pricing. If they can't afford ten hours, maybe we do only six. If they can't afford the full package with all the products, maybe I'll tweak what I'm offering and try to make it work. As long as I'm valuing my time appropriately, then I am comfortable customizing packages based on the clients' budget. A lot of my favorite weddings are those for which I negotiated the prices. When you negotiate, you are open to the possibilities of growing your business and your portfolio. You just have to make sure you're comfortable with the final deal, because if you feel like you're giving away the farm, you won't do your best work, and that doesn't help anybody.

Touching moments like this one in the back of the limo make for great images, and they also go a long way toward establishing your worth as a photographer. Remember that pricing is all part of the package; it's about the value you provide as an artist. If you can provide a premium product, then you should have confidence in the rates you charge. Contax 645, 80mm lens, ISO 200, f/2 at 1/500 sec. Fujicolor Pro 400H film rated at 200.

15 Building an Ongoing Client Base

There is a natural progression from wedding photography to child and family portraits. People get married, start families, and need portraits. Offering child and family photography has always been a natural step in my business.

My wedding clients know that I photograph everything from maternity portraits through full family photos. Many call me when they're starting their families, and I've been working with some clients consistently for the past seven or eight years. All told, I do about fifty portrait sessions a year. Roughly half of those are just kids or babies, and the rest are families.

My portrait business comes mostly from former clients and word-of-mouth referrals. I mention to all of my wedding clients that I do this kind of work, but I don't aggressively promote that side of the business to my existing client base. It's a very soft-sell approach. When someone is interested in my child and family work, I refer the person to my website for that market: www.josevillakids.com.

Promoting Your Work

Over the years, I've run a few promos through local businesses. I sell them cards for portrait sittings, which they can distribute to their customers as thank-you gifts. For example, a local real estate agent bought a set of cards for $500 apiece (the normal price of the sitting would have been $750, so there's a discount built in). She distributed the gift cards to her clients who closed on home purchases. Her clients then redeemed the cards for free portrait shoots, and all they had to purchase from me were the prints or album. This promotion exposed me to dozens of new clients, many of whom came back for future sessions. I've been photographing some of these clients for years now! The promo worked so well that I re-created it with some other real estate agents and professional service providers in the area.

ABOVE This child wasn't participating in the shoot much until I asked him about SpongeBob SquarePants. Then he was all ears! Learning about the child's interests helps create a connection, which goes a long way toward making great portraits. Contax 645, 80mm lens, ISO 200, f/2 at 1/1000 sec. Fujicolor Pro 400H film rated at 200

152

PAGE 150 After placing these sisters in ideal light, I asked them to get close and embrace each other and the dog. The image shows their attachment to their pooch and to each other. To me, this is what capturing great life moments is all about. Put the subjects in good light, add a little direction, and the rest just falls into place. This image has an editorial feel that works very well in promotional materials and for submission to magazines and blogs. It captures the exact feeling that I want to promote across all of my work. Contax 645, 80mm lens, ISO 200, f/2 at 1/250 sec. Fujicolor Pro 400H film rated at 200

OPPOSITE BOTTOM Kids move fast! I'm always trying to find ways to slow them down while still letting them play, have fun, and express their personalities. For this session, I filled this vintage tub with bubbles so the child would be entertained. Contax 645, 80mm lens, ISO 200, f/2 at 1/125 sec. Fujicolor Pro 400H film rated at 200

ABOVE With window light shining from camera right, I set my camera to the widest available aperture and captured the baby's inquisitive look. This sort of image is simple and cute—perfect for promotional materials, websites, and blog posts. Contax 645, 80mm lens, ISO 200, f/2 at 1/60 sec. Fujicolor Pro 400H film rated at 200

RIGHT With a baby sister on the way, anticipation was high for both mother and child. Backlighting the subjects with window light, I focused on the baby's eyes as she looked up at her mother. Contax 645 80mm lens, ISO 200 f/2 at 1/60 sec. Fujicolor Neopan 400 film, rated at 200

I like to build collections of portraits that depict the growth of a family over time. I put these together in albums that show certain periods in the life of the family, such as the six-year history from maternity to kindergarten. I position my child and family work as an extension of the wedding imagery; I'm creating additional pieces of art for the family's fine art photography collection.

Creating Salable Consistency

Consistency is critical. I want the images and products from one stage of life to work in concert with those from another stage.

For this reason, consistency is critical. I want the images and products from one stage of life to work in concert with the images and products from another stage. I don't brand the child and family work differently or treat it as a separate business. It's very much all in the same style, with the same feel and the same look. Wedding clients who later use me for baby and family portraits will have a consistent set of materials across the board. It will look as if an art director planned out their family's images from the wedding all the way through the development of the family.

The products I use are similar. Families often have an album from the same company for both their wedding and their baby portraits. They have complementary display boxes, prints, and other items. When I go into my clients' homes, I can see my work as a growing collection, which is very gratifying. My clients love that they are building this collection as their family grows, and they are comforted by the consistency of the work and the products. Significantly, they know what to expect and can plan ahead for how it will fit into their home.

I apply the same photographic principles to my child and family portraits that I use in my wedding images. I put my subjects in beautiful, soft light. I clean up background elements and avoid props that will date a photograph. I work with shallow depth of field and overexpose images for my signature color and tonality.

I also try to work outside as much as possible during the good times of day for

fine art wedding photography

OPPOSITE I love using a macro lens for close-ups of babies. It allows me to document tiny details like their feet, eyelashes, or lips. It also carries on the style of imagery that I establish with my clients during their wedding, especially the shallow depth of field and selective focus on the eyes and lashes. This sort of consistency helps clients better visualize ongoing collections of images—from wedding to maternity to babies and beyond. This image of the baby's long lashes is both adorable and artistic. Moms love this sort of photo! Canon EOS-1v, 100mm lens, ISO 1600, f/1.2 at 1/30 sec. Kodak T-MAX P3200 film rated at 1600

natural light. Scheduling sessions during these times can be a challenge, especially with younger children or babies, so I have to be flexible and work with parents to coordinate with the child's schedule. Ideally, though, I'll work in light similar to what existed at the clients' wedding to achieve a cohesive look and feel to the images.

My child sessions have evolved as a way to capture a day in the life of a child. I try to arrive at my client's home as the child is waking up from a nap, preferably in the morning when he or she is more alert and interactive. I photograph the child getting ready for the day, and then we go out and play. We run and jump and have fun. Then we wind down again for the end of the day or a nap.

Of course, photographing kids comes with its own set of challenges. They don't sit still for long, which means I have to move around a lot because I shoot with such a shallow depth of field. I'm constantly chasing them around, and I get a lot of

blurry shots. Out of thirty-six exposures, maybe twenty are in focus. But that motion is part of the fun, and it can make for some great images. Overall, I love photographing kids. They don't get embarrassed. They do whatever you ask without the inhibitions that often hamper adults. With kids, you can get as goofy as you want and really have fun with your sessions.

As with wedding photography, it pays to do your research ahead of time so that you can make a quick connection with your subject. I always learn about the child beforehand. What's his favorite cartoon? Favorite song? What toys does she play with? Then, during the session, I ask a lot of open-ended questions and try to find common ground. Once I get the child's attention, then I can start working with her in a fun way.

In general, I like to conduct sessions at the family's home. It's best to photograph kids in an environment where they're comfortable. Plus, if we're working in the home, the images will have special meaning for the family as time moves along.

Cohesion. Consistency. Color. Quality. Think of these elements as the four *C*s of fine art wedding photography (well, three *C*s and a *Q*).

Prioritizing cohesion helps you create collections of imagery that flow well and hold strong artistic appeal from beginning to end. This is so important when dealing with artistically inclined clients. The fine art approach grew from the idea of creating more cohesive image

Conclusion

collections, not disparate piles of images that have no emotional, artistic, or thematic connection. Today's high-end wedding clients want the full package, which means telling their story from beginning to end, accentuating the wedding design, and tracing the artistic themes throughout. You make your clients look good when you place them in a beautiful story of their wedding. And when you make your clients look good, you look great.

I've said it over and over in this book: Consistency is critical. Consistency in imagery. Consistency in service. Consistency in quality. Image color and lighting should be consistent. Your service should be superlative from first contact through final delivery. The quality of your products and final offerings should be universally impeccable. To truly provide a high-end, fine art experience, there can be no weak links.

Color, born from a very specific approach to light, defines the fine art look. In my shooting formula, pastel colors and warm, soft light define the imagery. Black-and-white shots punctuate the image collections, but color is what really draws in my clientele. My clients want light, airy images in which color portrays a sense of carefree happiness. This is the way people want to remember their big day. So help them. Put their story into an idealized setting and apply color in a way that helps them recall their wedding in the best possible light.

Quality should run through everything. This almost goes without saying, but I'll say it anyway: If you want to deal with a high-end clientele, you need to deliver premium quality. Know your equipment. Know your exposures. Know how the images will reproduce. Delivering quality starts from the minute you start planning a wedding, continues through every careful exposure you make, and extends into your postevent service.

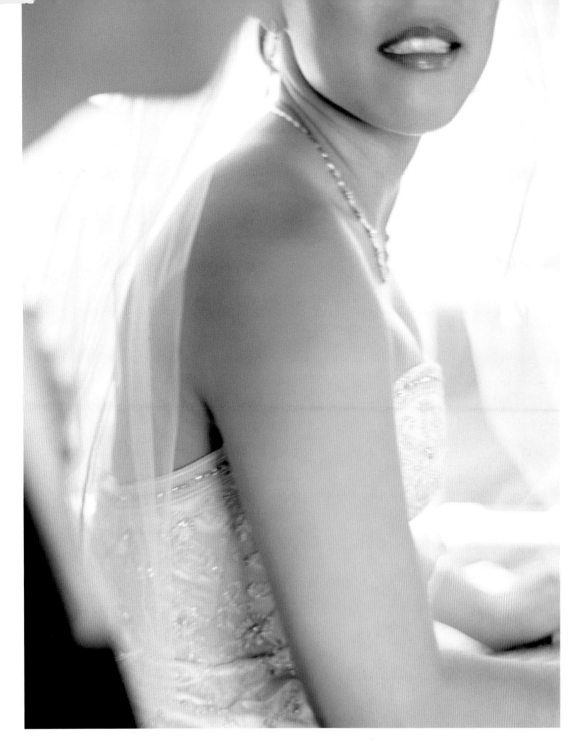

Remember, success in today's market is all about standing out in a good way. It's about distinguishing yourself from the legions of average photographers out there and carving a successful niche that will last for years. The Fine Art Approach is one path, one mind-set that can help you move your business in the direction you want it to go. The framework has been established. The philosophy is in place. What you do with it from there is up to you.

The bride and groom were in their getaway car, so I cropped in close to get her soft expression as she looked at her new husband. Exposing for shadow and working with my Aperture Priority set to f/2, I captured this moment before they sped away. Even though I work quickly in moments like these, I always keep in mind my critical shooting principles: cohesion, consistency, color, and quality. Contax 645, 80mm lens, ISO 200, f/2 at 1/30 sec. Fujicolor Pro 400H film rated at 200

Index

NOTE:
Page numbers in *italics* include photographs and/or captions.

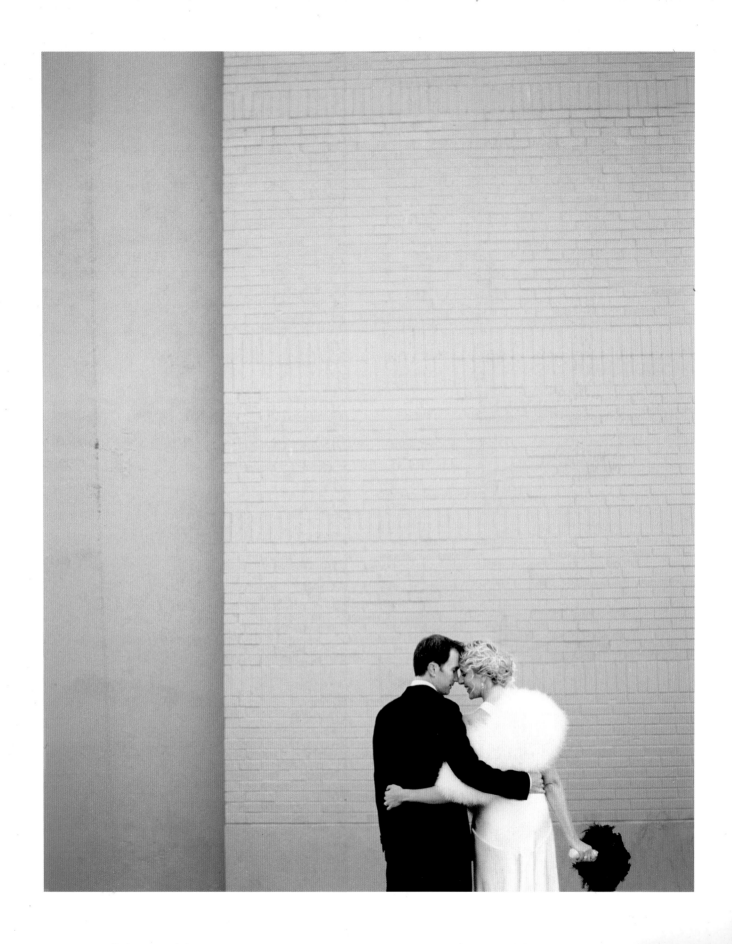